LYME REGIS & AROUND

THROUGH TIME

Steve Wallis

AMBERLEY PUBLISHING

First published 2014

Amberley Publishing
The Hill, Stroud, Gloucestershire, GL5 4EP
www.amberley-books.com

Copyright © Steve Wallis, 2014

The right of Steve Wallis to be identified as the
Author of this work has been asserted in accordance with
the Copyrights, Designs and Patents Act 1988.

ISBN 978 1 4456 3615 3 (print)
ISBN 978 1 4456 3643 6 (ebook)

British Library Cataloguing in Publication Data.
A catalogue record for this book is available from the
British Library.

Typesetting by Amberley Publishing.
Printed in Great Britain.

Introduction

In common with others of the *Through Time* series, this book pairs old and new photographs of the same subjects to allow the reader to see how they have, or perhaps have not, changed. The old images belong, more or less, to the first few decades of the twentieth century. They generally come from postcards, which can be fascinating themselves in the subjects that have been chosen and the way they have been presented. I should add that the dates given for these images are estimates.

When taking the modern views that accompany them, I have tried to use the same location as the previous photographer. Sometimes this was not possible as some views were blocked by vegetation or housing that has appeared in the last century or so, and I also wished to keep on public rights of way. In such instances, I got as close as possible while still getting a reasonable view of the subject.

I took my photographs during spring 2014. Two related factors that did not always allow me to get the pictures I wanted were the Lyme Regis Environmental Improvement Scheme and landslips. The former is aimed at protecting the town from the impact of the latter, and has been running in a phased format for nearly ten years. Some of the ongoing works can be seen in my photographs of the eastern end of the seafront.

Recent landslips, caused largely by the severe storms of the previous winter, made only limited access possible to the stretch of coast between Lyme Regis and Charmouth, although landslips over many years have long closed (and often destroyed) the old coast road between the two settlements. The same factor has also closed a section of the wonderful footpath through the 'lost world' of the Undercliff between Lyme Regis and Seaton.

The subjects in this book are divided into chapters loosely based on particular themes. The dates given for the old views are guesses, with varying degrees of confidence.

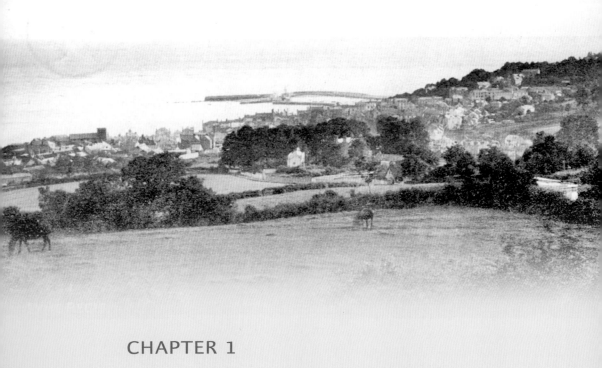

CHAPTER 1

Views of Lyme Regis

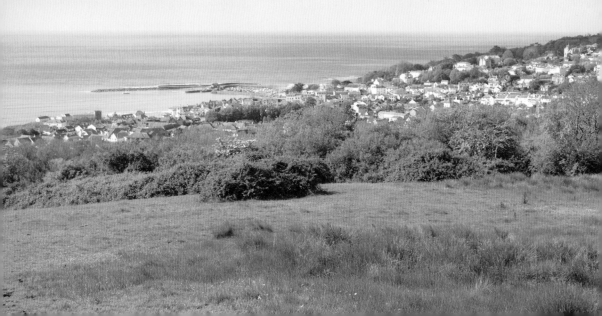

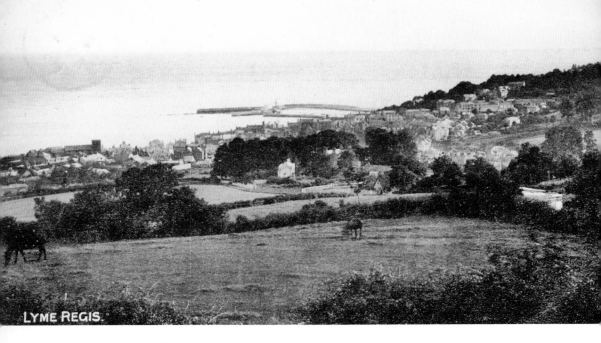

LYME REGIS.

View From Timber Hill, *c.* 1905

We start with two views from Timber Hill on the east side of Lyme Regis. Though a distant shot, the old photograph shows some of the distinctive features of the town: the parish church on the left, the harbour of The Cobb projecting into Lyme Bay, and the spread of the town uphill from its old centre down by the shoreline. My photograph, which was not taken from exactly the same spot, shows that not that much has changed; perhaps the main difference is the spread of housing up the hillside on the right.

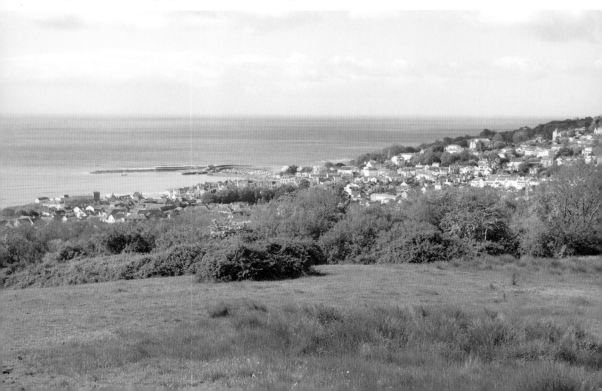

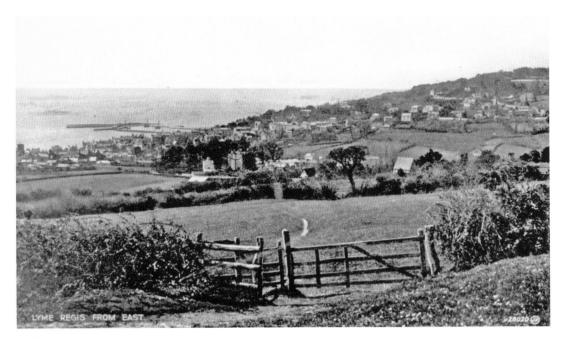

Lower Down the Hill, *c.* 1930

Here is a second example of the view from the east side of town, and in this case I think I have identified the location from which the old photographer took his picture. I believe the gate in the foreground is on the public footpath that runs from the National Trust's nature reserve called The Spittles, down to Charmouth Road and into Lyme Regis. Today, the hedge obscures the view from this exact spot, so my picture is taken from the gateway itself.

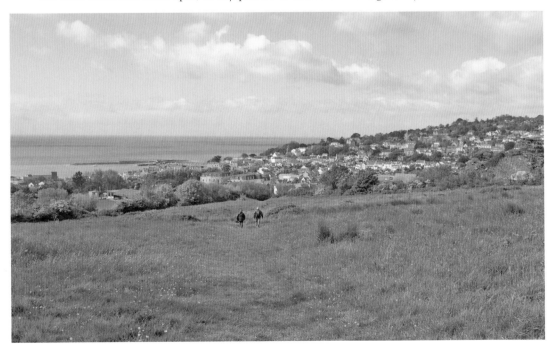

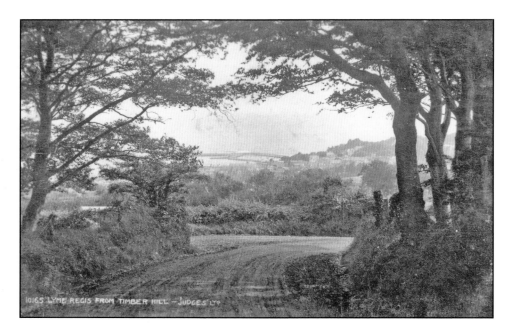

10165 LYME REGIS FROM TIMBER HILL - JUDGES LTD

The Road Called Timber Hill, *c.* 1925

Today the name Timber Hill is also used for a back road that loops off Charmouth Road, a little higher up than the previous viewpoints. However, when the old photograph was taken, this road was the main route into Lyme Regis from inland Dorset. As we look at these views, the road bends off to the right round the corner, and another route joins it from the left. Today, this is a short length of track leading to The Spittles, but when the old picture was taken it was another road that ran over the clifftops from Charmouth. It has long been closed (and in some cases lost) because of landslips.

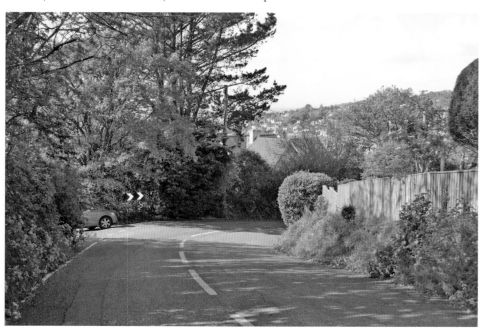

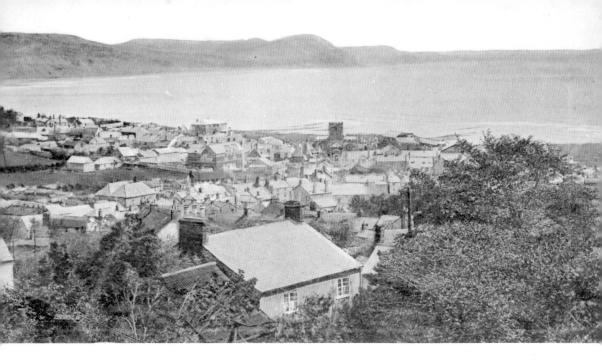

Views from the West, *c.* 1910 and *c.* 1920

Going over to the other side of Lyme Regis, we see these views of the expanding town. In all these views, the tower of the parish church in Church Street is prominent, and the centre of the old town is generally to the right of it. The earlier of the two pictures was, I think, taken from high up in a property on View Road or Woodmead Road. Its foreground shows the suburbs had grown up even by the early twentieth century, largely thanks to the tourism industry. My shot was taken from Hill Road, a little closer to the town centre, which was about the only place on this western side of Lyme that I could find a view over the town rooftops. The other old picture was taken from some distance further out, probably somewhere near the Uplyme Road, and illustrates the open fields in this area that have since been developed.

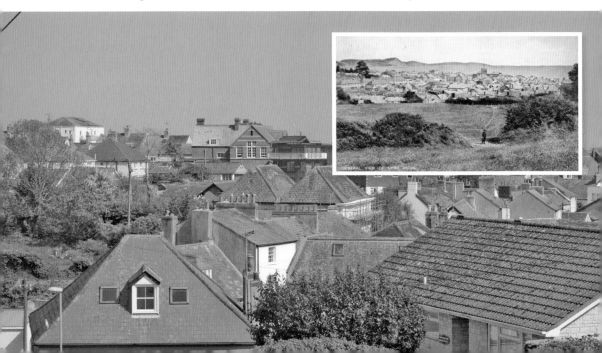

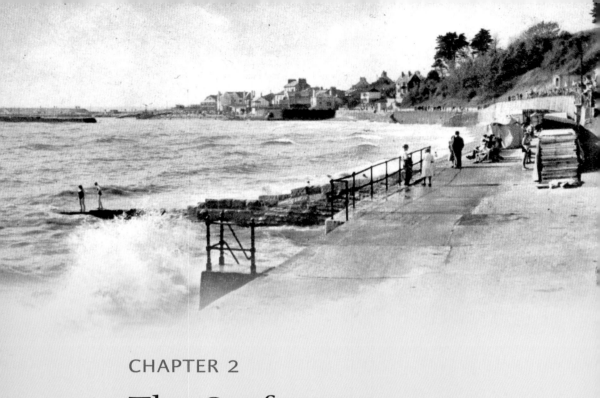

CHAPTER 2

The Seafront

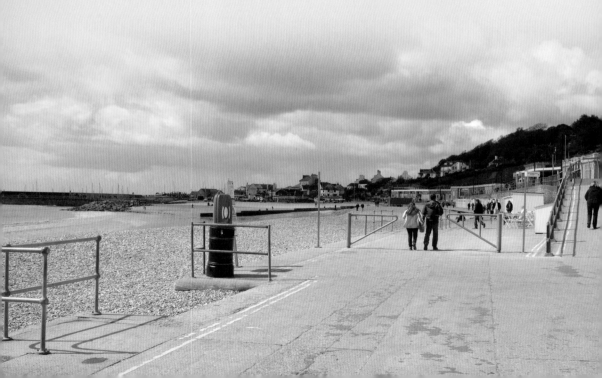

East Cliff, *c.* 1930

In this chapter, we will look at views along Lyme Regis' long seafront, beginning at East Cliff. In the old view, we look east towards the little promontory from where the coast bends northward as Church Cliff below the parish church. My picture was taken from a higher vantage point, since much of the area was cordoned off for part of the Lyme Regis Environmental Improvement Scheme.

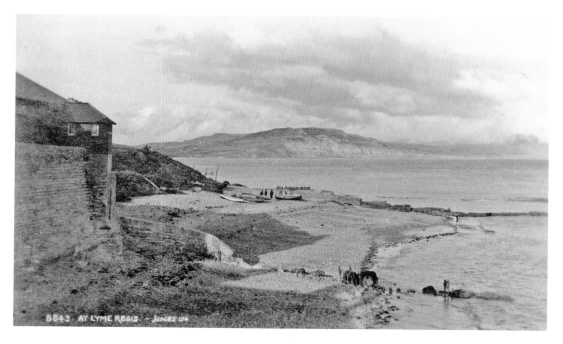

A Wider View of East Cliff, *c.* 1925

Here we have a wider view of East Cliff from the town's sea walls. My picture shows how much more extensive these are today, as well as illustrating the Lyme Regis Environmental Improvement Scheme in progress. The building on the left is part of what is now the Marine Theatre. The wall at the end of the beach may be the same in both pictures, and Golden Cap is in the cloud of the old picture.

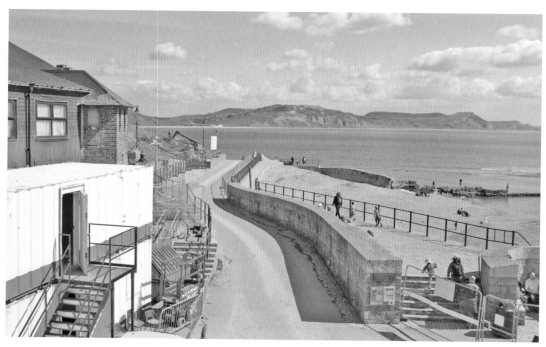

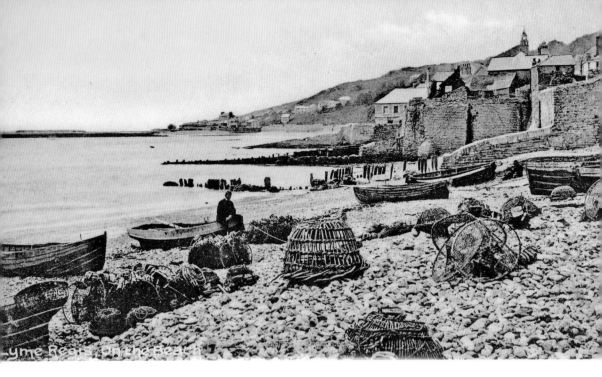

Fishing Gear, c. 1905

The viewpoint here is on the far wall in the old photograph, and looks back across Lyme Regis' seafront. The impression today is that the local fishing industry is concentrated in and around The Cobb, but the old view illustrates how extensive that industry once was. Today, the paraphernalia of fishing at this end of town is replaced by beachcombing visitors.

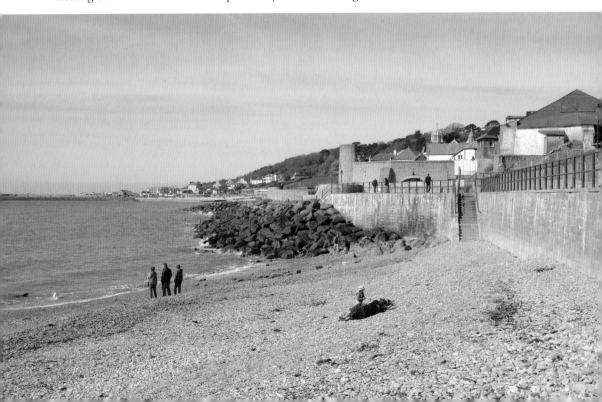

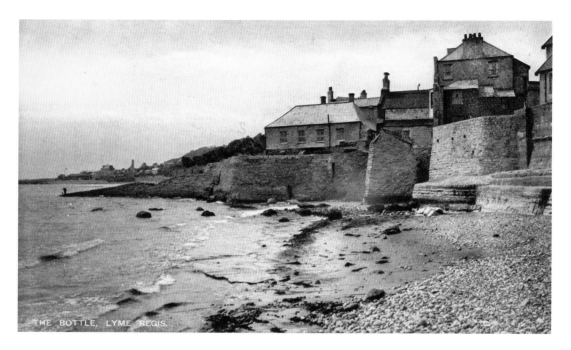

THE BOTTLE, LYME REGIS.

Assembly Rooms, _c._ 1925

We move forward towards the Buddle, the name given to the River Lim at its mouth. Comparing the old and new pictures, the appearance of substantial amounts of rock armour to blunt the force of the sea is very noticeable. Another change is the loss of the building in the centre of the old picture – this was the Assembly Rooms, located at the bottom of Broad Street where today there is a car park.

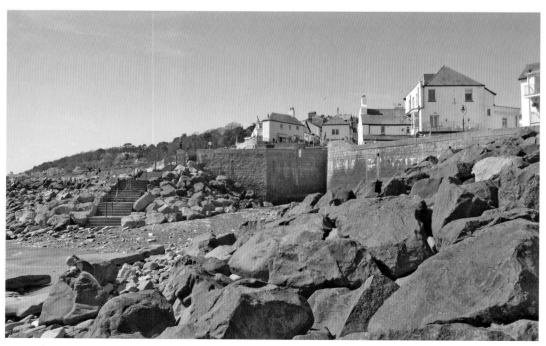

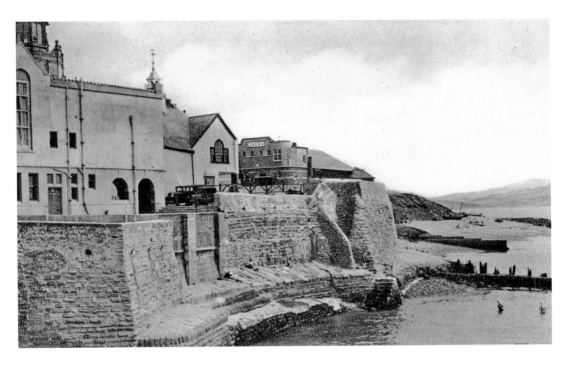

Lyme Regis Museum, *c.* 1925

Up on the sea walls, we turn back for another view much changed by the town's sea defences. Today, the building on the left is the museum, and behind it we glimpse the tower of the Guildhall. At centre there is the Marina Theatre, which was a cinema when the old shot was taken – not the usual way around until recently!

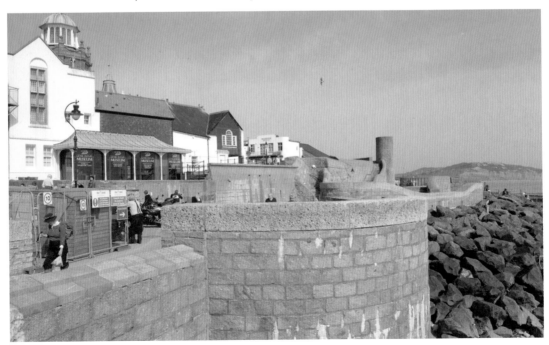

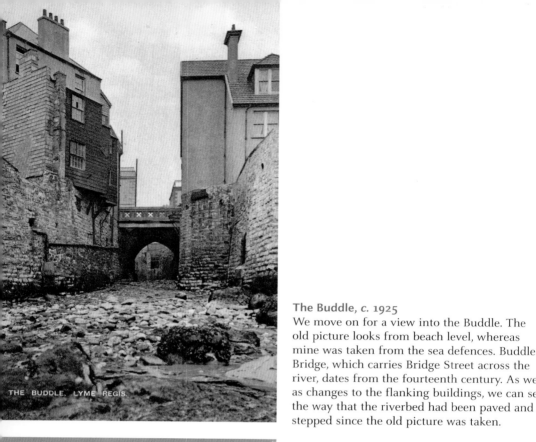

THE BUDDLE. LYME REGIS.

The Buddle, c. 1925

We move on for a view into the Buddle. The old picture looks from beach level, whereas mine was taken from the sea defences. Buddle Bridge, which carries Bridge Street across the river, dates from the fourteenth century. As well as changes to the flanking buildings, we can see the way that the riverbed had been paved and stepped since the old picture was taken.

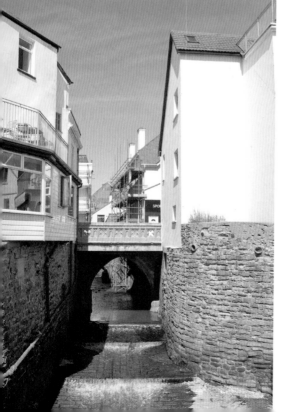

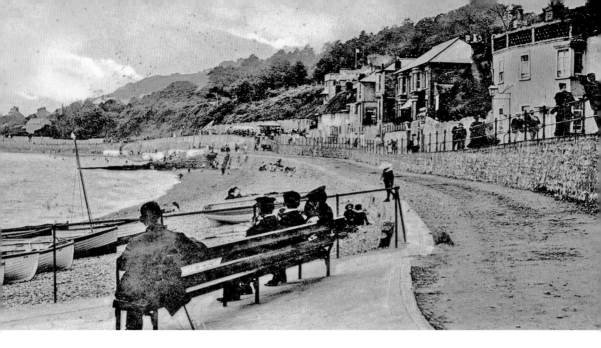

Marine Parade, *c.* 1910 and *c.* 1935

In the rest of this chapter we take a stroll along Marine Parade, heading west towards The Cobb before turning around to retrace our steps. We start just past the spot where today there is a car park at the bottom of Broad Street, with the old Alcove Hotel on the right-hand edge of shot. There has been a promenade at Lyme Regis since 1771, but the viewpoint of these three photographs is at the lower level, called the Cart Road. Its name indicates that it was intended to separate horse-drawn vehicles from the promenaders, and indeed it is still used by some vehicles. There have been quite a few changes to Marine Parade, many of them related to sea defence, and here we note that the projection with the seat does not survive today.

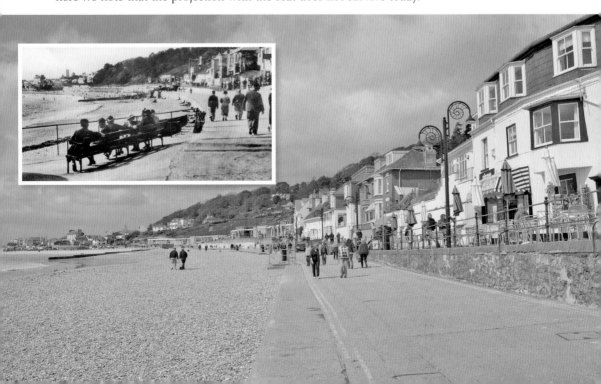

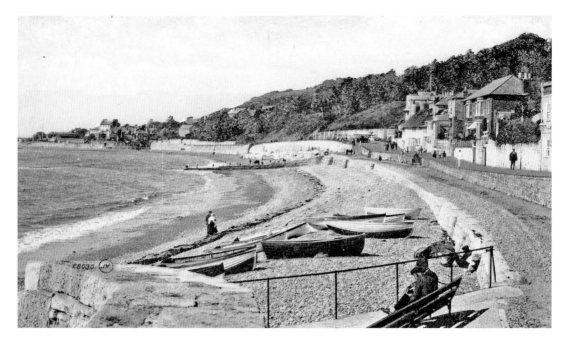

Seafront Properties, c. 1905

ThisEdwardian image taken from close to the previous viewpoint, shows not only of the beach being used for boat storage, but also a good view of the fascinating group of properties, many dating to the early nineteenth century, that line this section of Marine Parade. Clearly, as the town developed as a tourist attraction, this was a prime spot where people wanted to live, and architects obliged with some fine advertisements for their profession. The area has not remained unchanged, though. Near the right edge of both views, there is an area of open ground that seems to be a garden, and the site, next to the former Alcove Hotel, has since been built on, as my picture shows.

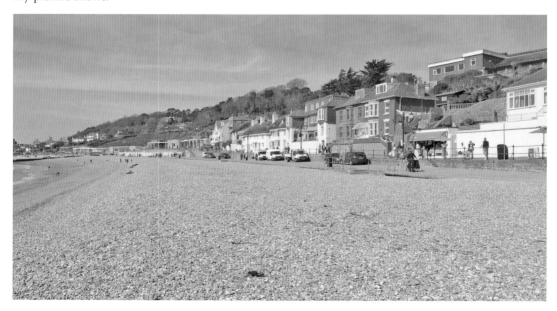

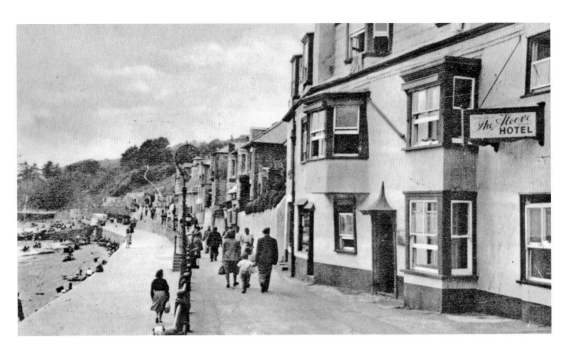

The Alcove Hotel, *c.* 1935

Now up onto the promenade for a closer look at the Alcove Hotel, which occupies the right of the old picture. This building dates from the early nineteenth century and was originally a two-storey cottage; the third storey was presumably added when the place became a hotel. Today, it is a gift shop, ice cream parlour and coffee shop.

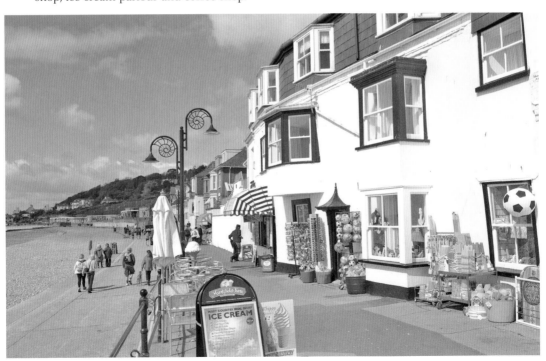

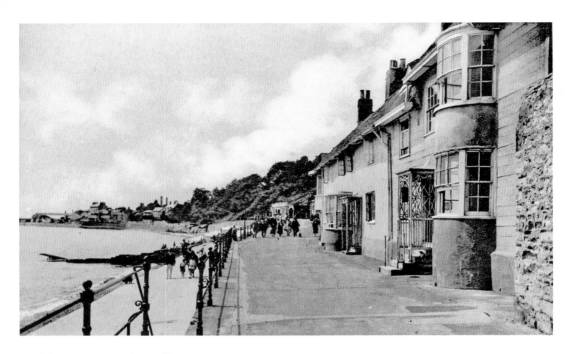

Madeira Cottage and Harville Cottage, *c.* 1930
We head several doors along Marine Parade for a view of a pair of attractive seafront cottages. In the foreground, with the two-storey bow window and trellis porch, is Madeira Cottage, built not long before 1820. In the old picture, the frontage is weatherboarded; it has since been plastered over. Further on is Harville Cottage, built onto the end of Madeira Cottage not long after the latter's construction.

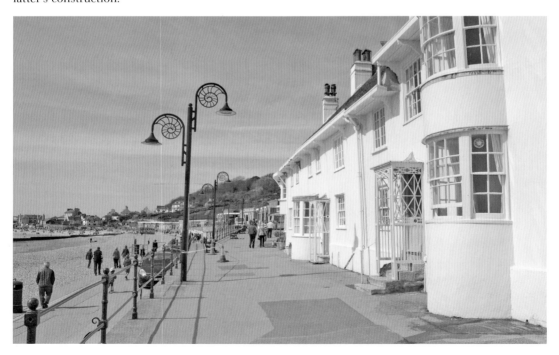

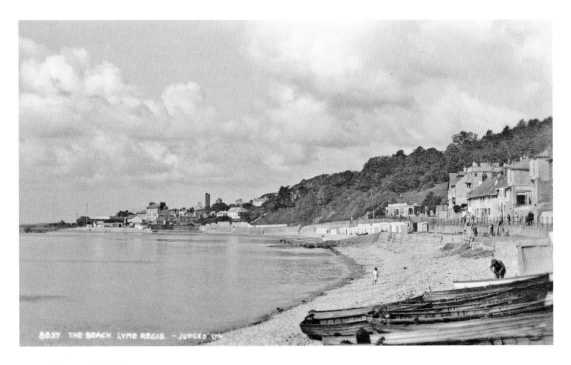

8837 THE BEACH LYME REGIS. - JUDGES' LT

Cement Works, *c.* 1920

The old picture here gives a clear view of the remainder of the seafront round towards The Cobb, including an odd collection of booths around the end of the Cart Road. To the left of centre, there are two tall chimneys close together; these belonged to a cement works in the area beyond The Cobb where today there are chalets and car parks.

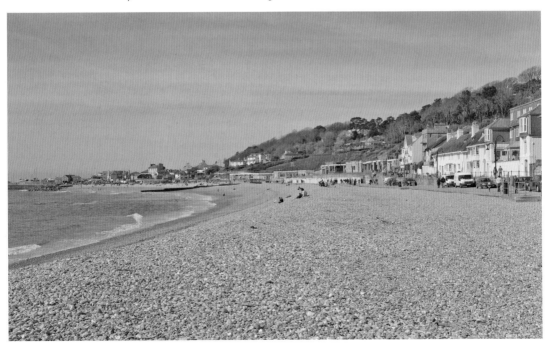

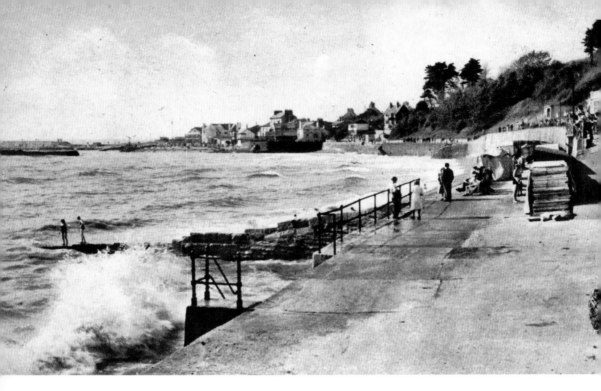

On the Cart Road, *c.* 1930

We next back off the beach to a point close to the end of the line of older properties on Marine Parade – the furthest point that most vehicles can reach on the Cart Road today. The view here illustrates some of the changes that have taken place on this section of the seafront.

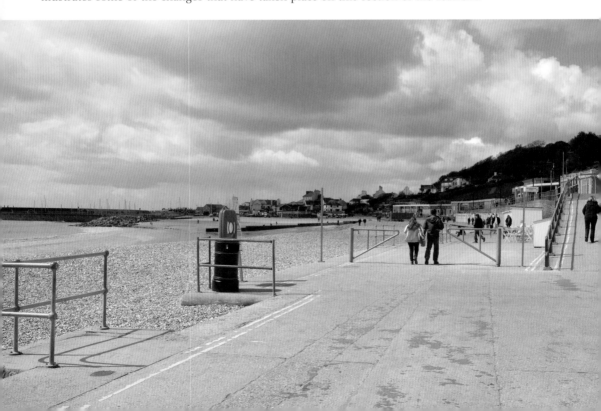

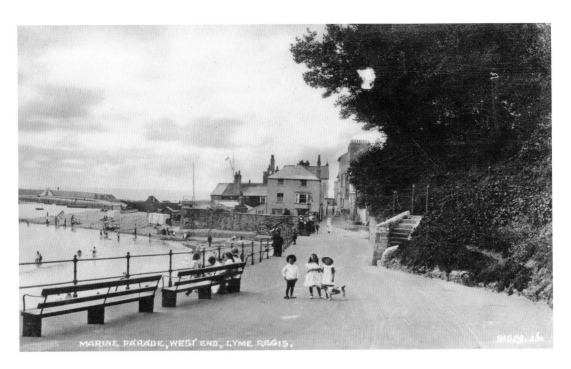

MARINE PARADE, WEST END, LYME REGIS.

Towards Cobb, c. 1905

We move forward about 100 yards, getting a clearer view of what was once a detached area of the town beside The Cobb, and which is called simply 'Cobb'. On the right of the old photographs, we see the cliff at the base of Langmoor Gardens and steps that led up to them. Today, By The Bay restaurant is on our right.

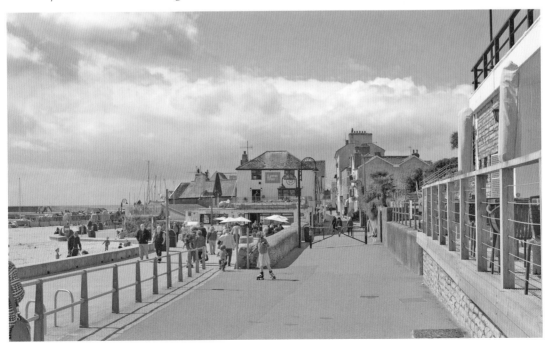

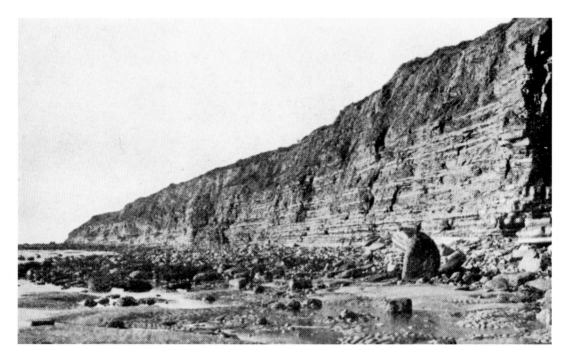

Devonshire Head

We go through Cobb and past the chalets and car park beyond for this look along the coast. The old picture was entitled 'Devonshire Point', although 'Devonshire Head' is generally used today. The cliffs here are made of Blue Lias limestone and mudstones, which date back 200 million years to the early Jurassic period. The limestone was quarried for use in the cement works at Cobb.

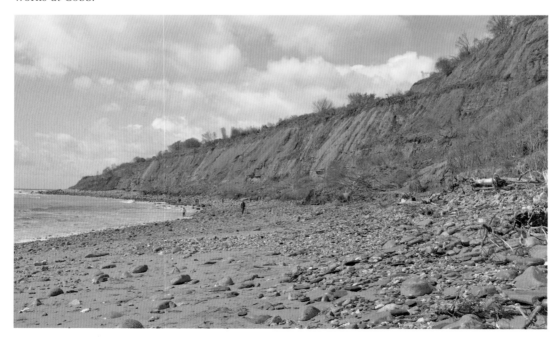

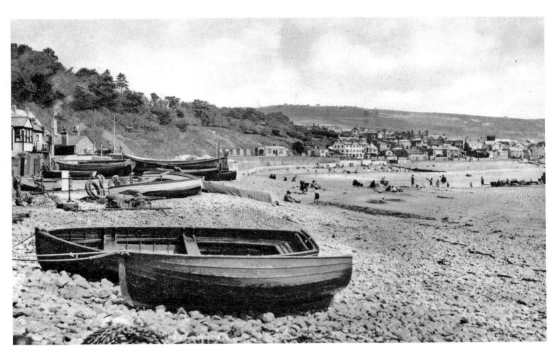

Starting the Return Leg, *c.* 1925

Heading back into town, our first stop is on the other side of Cobb, where the presence of boats in the old image illustrates that this area was a working port. My view shows no boats, but there is actually a boatyard just behind where I took my picture.

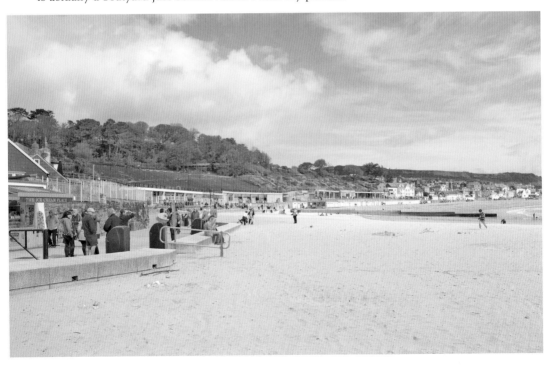

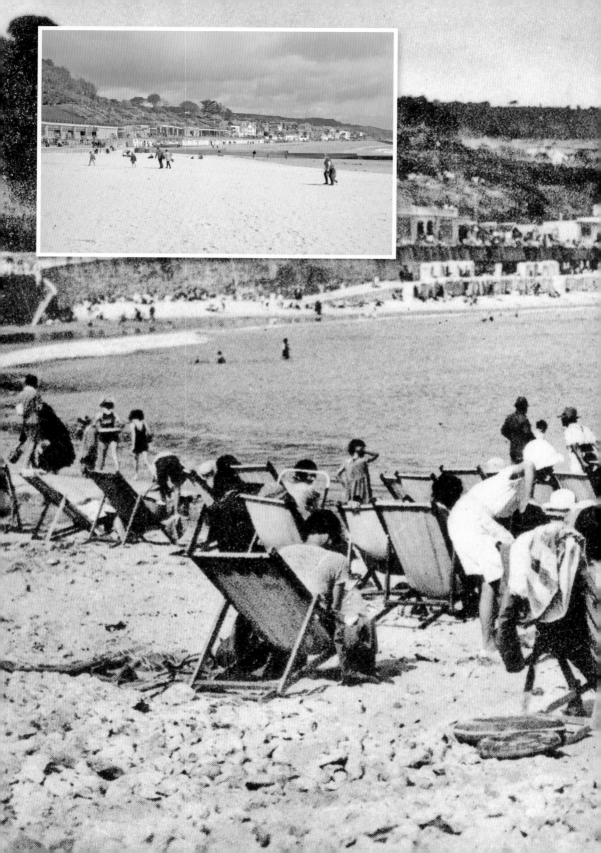

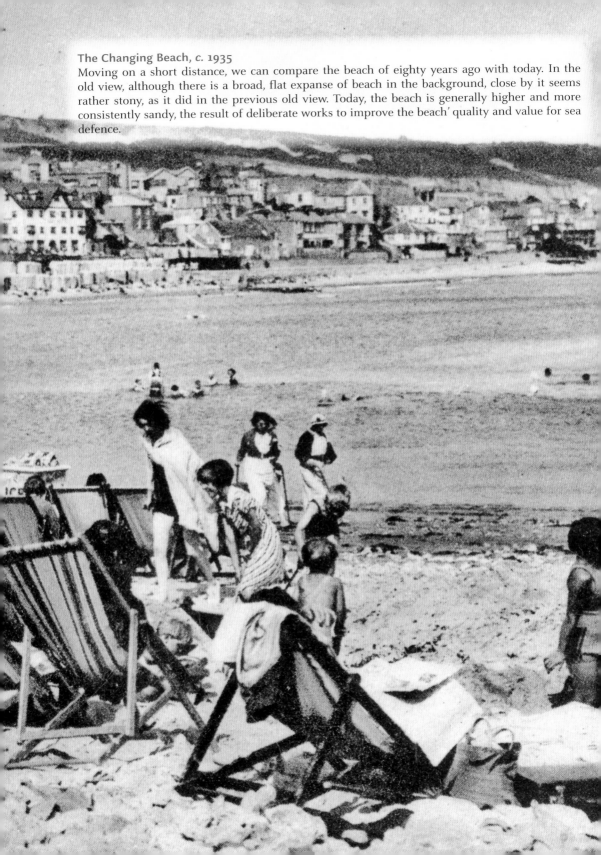

The Changing Beach, *c.* **1935**
Moving on a short distance, we can compare the beach of eighty years ago with today. In the old view, although there is a broad, flat expanse of beach in the background, close by it seems rather stony, as it did in the previous old view. Today, the beach is generally higher and more consistently sandy, the result of deliberate works to improve the beach' quality and value for sea defence.

A Thriving Resort Then and Now, *c.* 1935

This pair of views illustrates again the change in height of the beach. In the old shot, Marine Parade has a much more elevated position above the sand, and there is also a more pronounced walkway (effectively the Cart Road) below it, just above beach level. Changes to the seafront meant I had to be a little further inland to get an elevated location, but you get the idea of a busy holiday resort then and now.

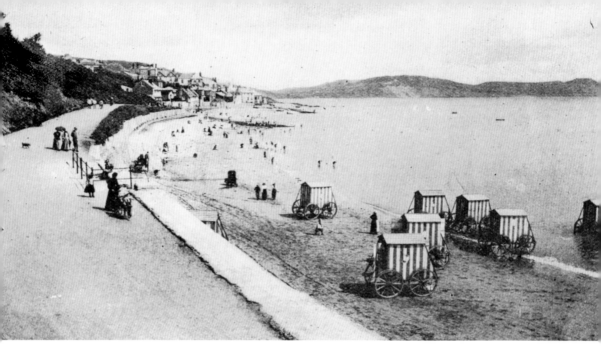

Langmoor Gardens, *c.* 1905
These two Edwardian images were both taken from Langmoor Gardens and show the steep, and potentially unstable, cliff that once hung over the central section of Marine Parade. Today, the cliff has been stabilised and there are a number of businesses along the parade. My shot was taken from the rooftop walkway above these businesses at the bottom of Langmoor Gardens. One of the Edwardian views shows a collection of bathing machines on the beach.

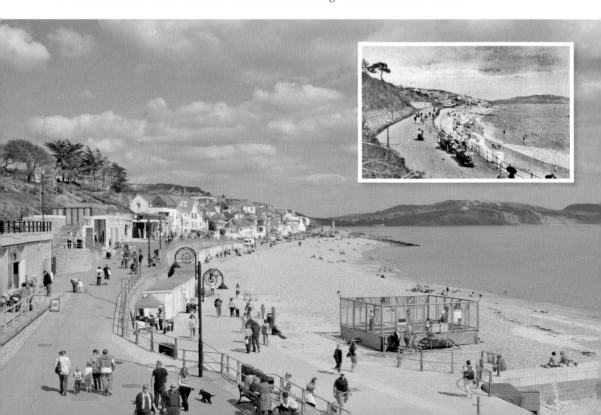

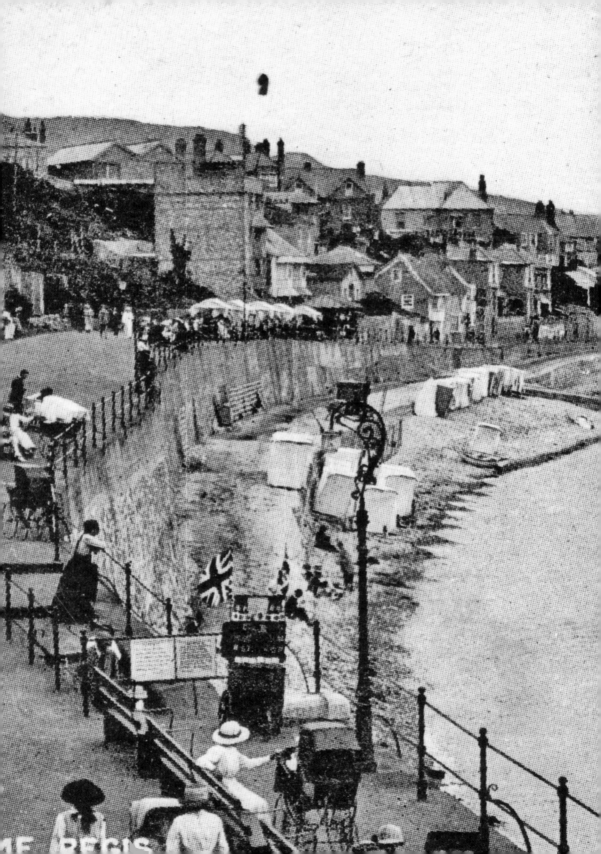

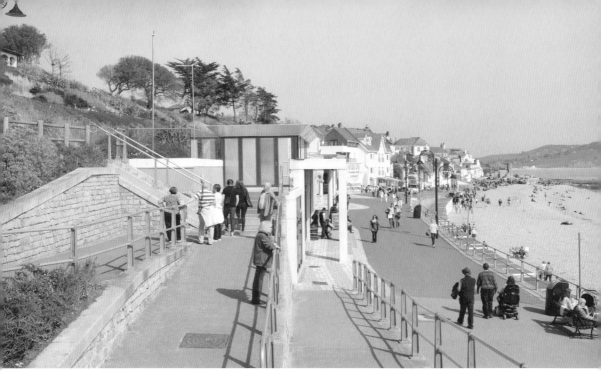

Langmoor Gardens, *c.* 1910

These old photographs are a little later in date than the previous. They were taken from similar viewpoints to the previous pair (although a lower one in one case) but they do have such a wide view and consequently show more detail. There are beach huts where the Jubilee Pavilion now stands, and beyond we see the three-storey property called Sundial. This was built in 1903, and the view of it is now partially blocked by the adjacent hotel.

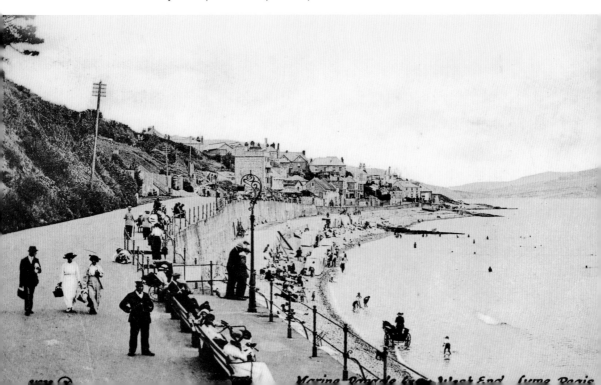

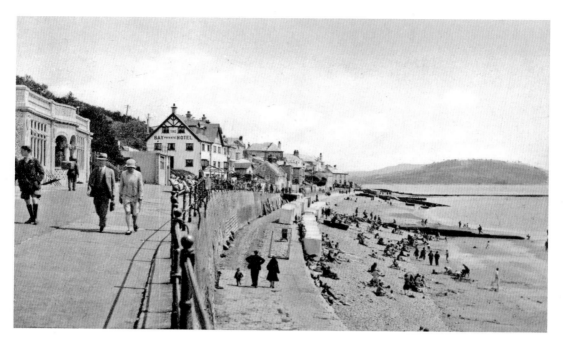

Corporation Shelter, *c.* 1925

Our next stop is just a little short of what is now the Jubilee Pavilion. It was built in 1924 and given the rather less glamorous title of 'Corporation Shelter'; it looks very new on the left of the old image. It was damaged by a landslip in 1962 and subsequently closed. As part of the extensive seafront works, it was restored and reopened in 2011, then given its present name on 20 May 2012 to celebrate the Queen's Diamond Jubilee.

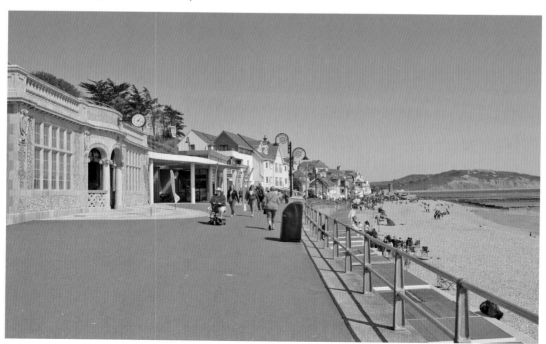

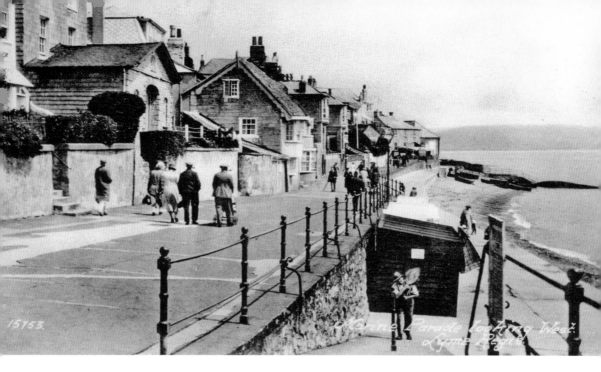

Early Nineteenth-Century Properties, *c.* 1925

We move on to the housing on Marine Parade. Library Cottage is partly within the left side of this view. There was a library here from 1839, and then around the turn of the twentieth century, architect Arnold Mitchell refurbished the building. Next to it is a three-storey property called Argyle, built in 1833 as a bathhouse. As the two views show, its porch has been altered considerably. Beyond is Benwick Cottage.

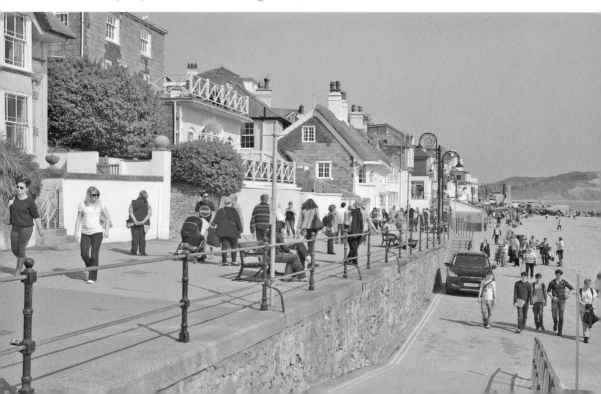

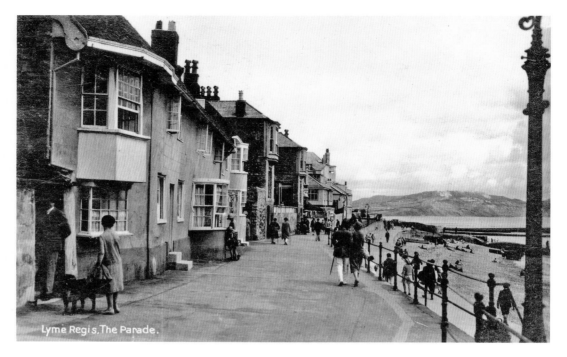

Lyme Regis. The Parade.

Benwick Cottage, *c.* **1935**

To finish this chapter we move on to a viewpoint just before Benwick Cottage. The latter is part of a terrace of three early nineteenth-century homes; the others are Madeira Cottage and Harville Cottage that we saw on the outward leg.

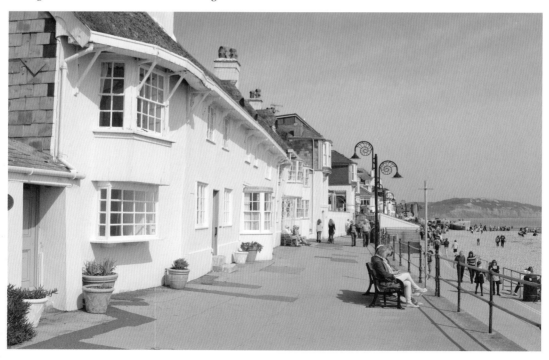

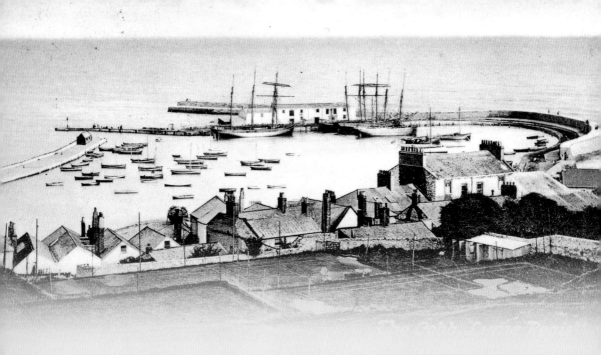

CHAPTER 3

The Cobb

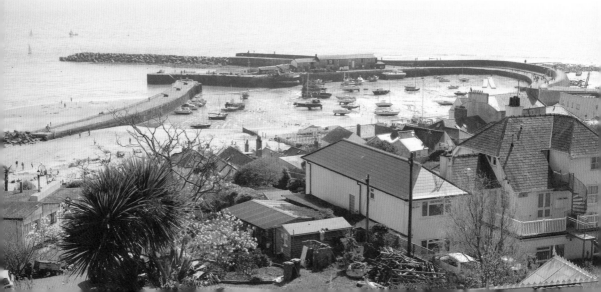

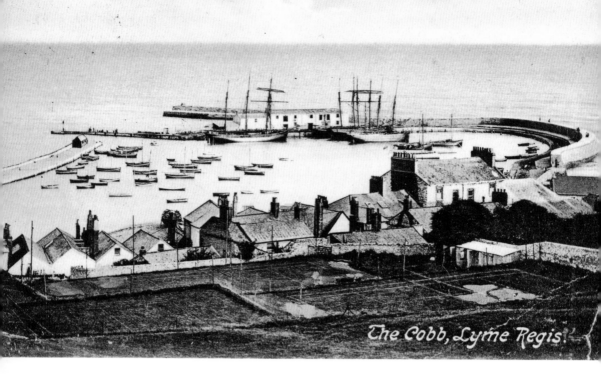

The Cobb, Lyme Regis

Three Views of The Cobb, *c.* 1900–05

In this chapter, we concentrate on Lyme Regis' most iconic feature, The Cobb. Records indicate that there has been a wall forming a harbour here since the late thirteenth century. Due to regular damage from storms as well as a need to improve the facility, it has been rebuilt and added to on many occasions since then. The Cobb has also featured in literature. Notably, it is the location where Meryl Streep's character spent her days looking out for her lost love in *The French Lieutenant's Woman*, and in Jane Austen's *Persuasion*, Louisa Musgrove falls and becomes unconscious after carelessly running down the steps from its upper to lower levels. I have

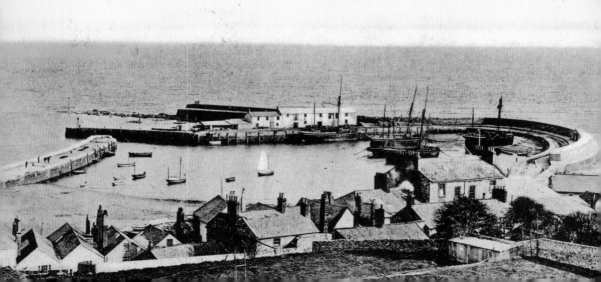

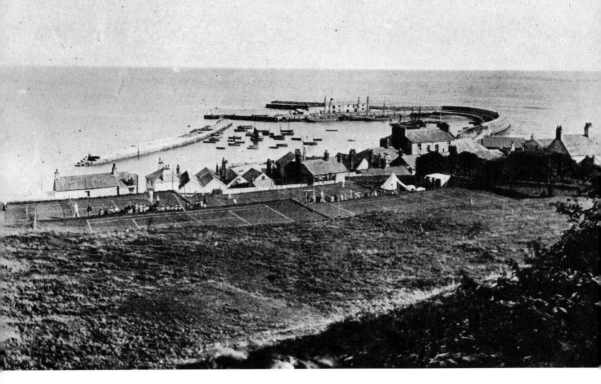

included three old views of The Cobb, all taken in the first few years of the twentieth century. They show the same features in general, but there is a fascinating variety of vessels within the harbour, and the foreground is also rather interesting. The viewpoint of all three shots seems to be Cobb Road, which runs down from Pound Street in the upper part of the town, and the photographers have recorded the tennis courts that were terraced into the hillside. One shot shows games in progress, and a tent perhaps used by the organisers of a tournament. This area has since been developed with housing, as my photograph shows, and there is also a sizeable hedge on this side of Cobb Road, so this was taken from higher up than the others.

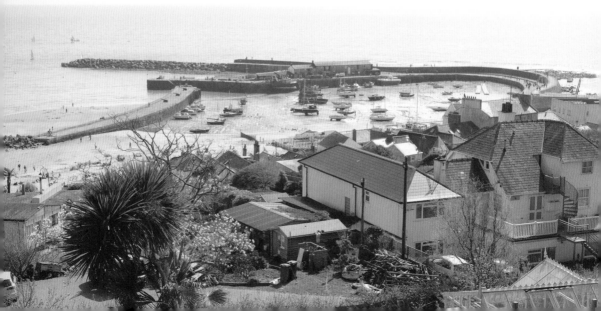

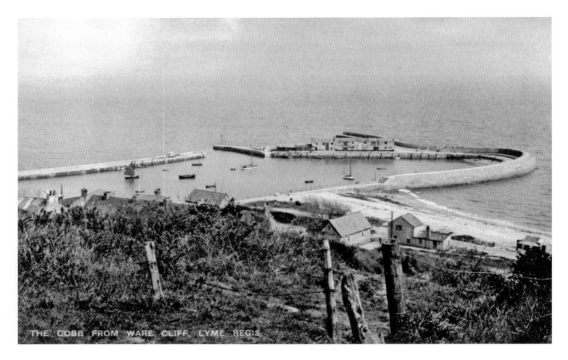

THE COBB FROM WARE CLIFF, LYME REGIS

The Cobb from Ware Cliff, *c.* 1930

The old picture gives an excellent view of how The Cobb looked some eighty years ago. The viewpoint is further to the west than the previous, in what is today a nature reserve at Ware Cliff on the edge of the town. I took my photograph by a seat on a small, levelled area beside the footpath that heads down the cliff here, and I suspect that the old photographer was at this exact spot.

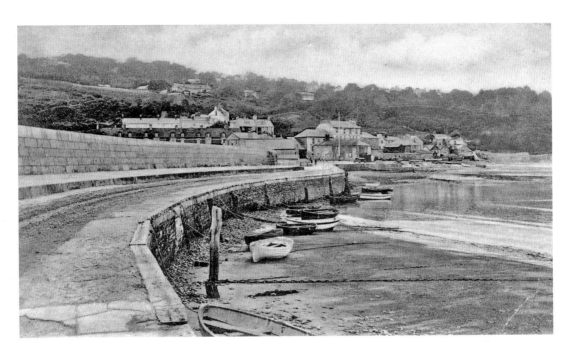

Down on The Cobb, *c.* 1900

Here we get a good idea of how The Cobb was constructed. An outer and higher wall of Portland stone, called the High Wall, forms the main protection, and within it there is a wider walkway with a step on one side. It is possible also to walk along the High Wall, but this is inadvisable in bad weather, especially as the surface is uneven. Parts of the Cobb were rebuilt recently as part of the Lyme Regis Environmental Improvement Scheme, and my picture shows evidence of ongoing repair work after the winter storms.

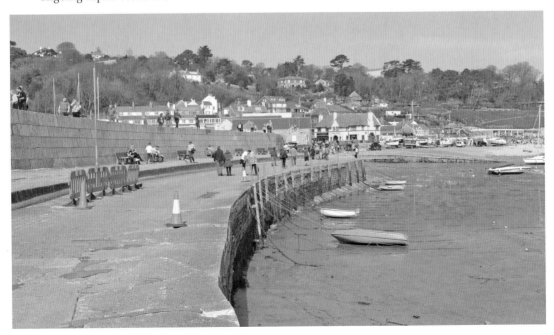

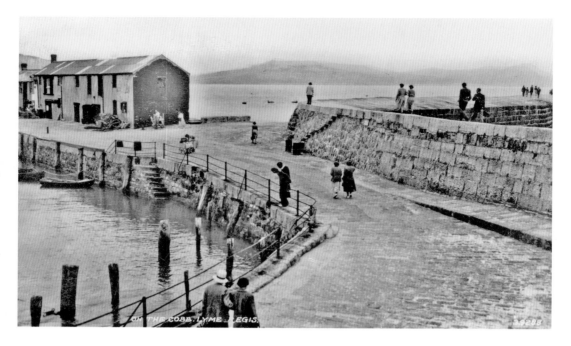

Looking Along the Cobb, *c.* 1935

Climbing onto the High Wall and looking in the other direction, we see more detail. The Cobb arcs around to the left, to the main area of activity. Here are buildings constructed soon after a major rebuilding of The Cobb in 1825, following massive storm damage the previous year. These were built as stores and perhaps offices, and today the nearest ones house the Marine Aquarium. The High Wall, however, follows an outer arm that heads further out to sea.

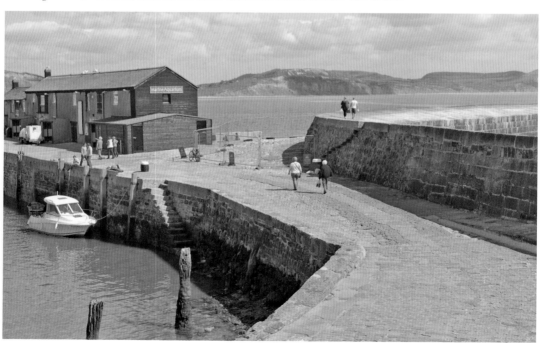

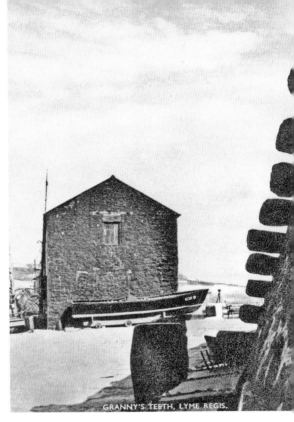

Granny's Teeth, c. 1910

If you look closely at the middle of the previous picture, you see a series of rough steps ascending the High Wall. Here they are close up, and this view explains their name – one that our ancestors saw nothing wrong with, but that today would be thought insulting – as they are reminiscent of a series of teeth with relatively wide gaps between them.

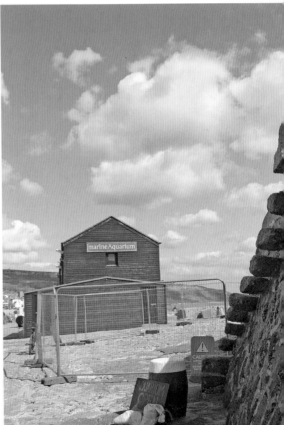

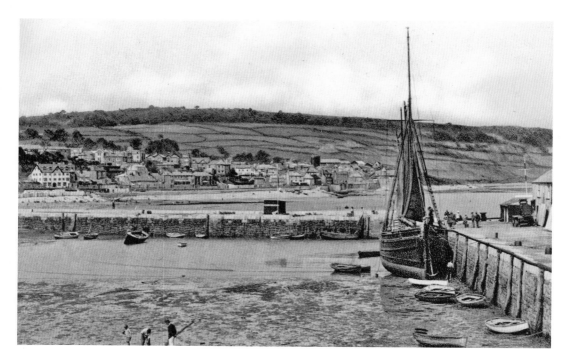

Across The Harbour, *c.* 1930

Back down on the walkway, we look across the harbour, with the far end of the buildings now on our right. In the old photograph, there is plenty of activity around the large vessel, while three boys seem to be digging for bait or shellfish in the harbour itself. Note also the contrast in the hillside of The Spittles and Black Ven in the distance – then mostly fields, today mostly landslip!

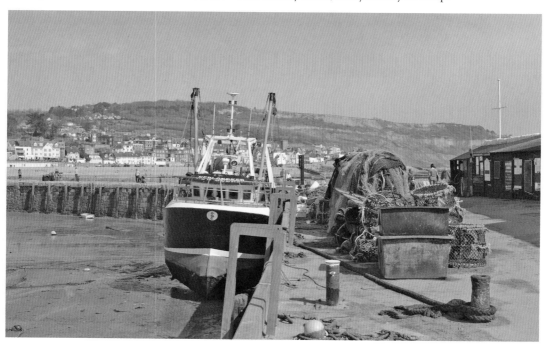

The Harbour, Lyme Regis.

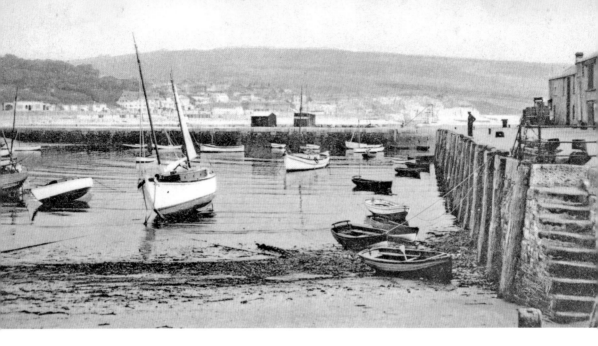

Steps, *c.* 1930

Shifting a few steps to our right from the previous view, we now see a flight of steps that leads down into the harbour. They seem unchanged today, although the edge of the wall in front has changed. This old picture was taken about a quarter of a century after many of the previous ones of the harbour, and here there is a noticeable increase in leisure craft.

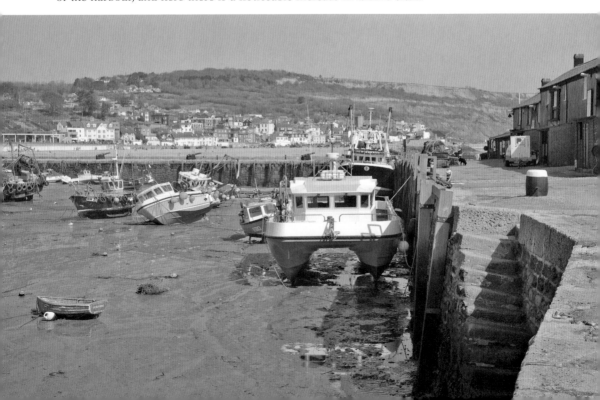

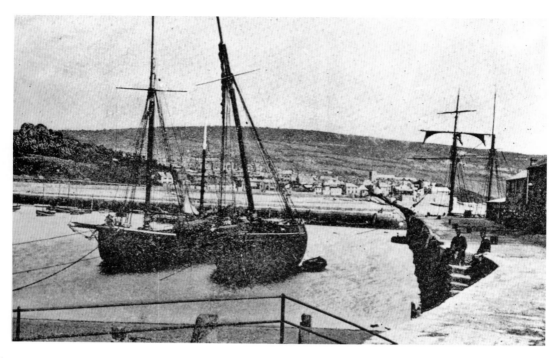

The Harbour Mouth, *c.* 1905

Here is an older view from a similar location. The harbour mouth is beyond the buildings on the right. The Cobb was extended here between 1842 and 1852, and the addition was called Victoria Pier after the reigning monarch. North Wall (more about this later) forms the other side of the harbour and its mouth.

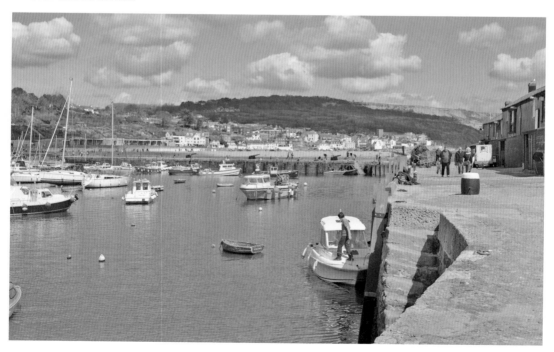

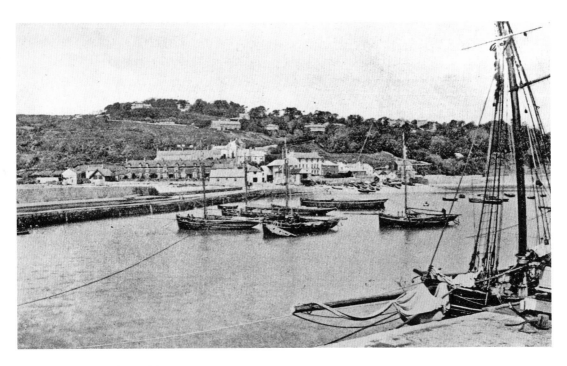

Cobb from The Cobb, *c.* 1905

We move forward a few yards on The Cobb for the first of three views back to dry land. One of the striking features of the old view is the relative lack of houses on the hillside behind Cobb. Also, the Cobb Arms, which occupies a prominent central location in my picture, is not present in the old view – there was a coastguard station on its site around the time the latter was taken.

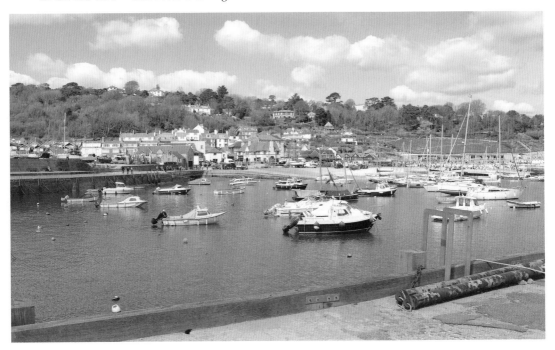

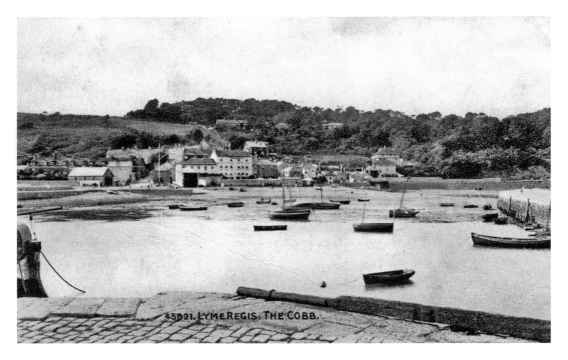

A Shift of Angle, *c.* 1910

We move further along for more of a face-on view of Cobb, which is an area reclaimed from the sea since the eighteenth century. The North Wall has now come into view on the right, and my shot shows some of the ornamental cannons that adorn it today. Over on the left in the old shot, we see part of the old cement works that we glimpsed from an earlier view on Marine Parade.

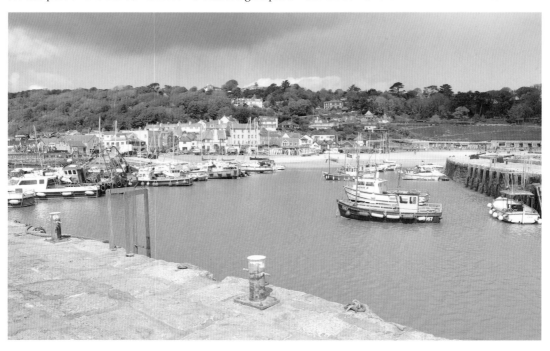

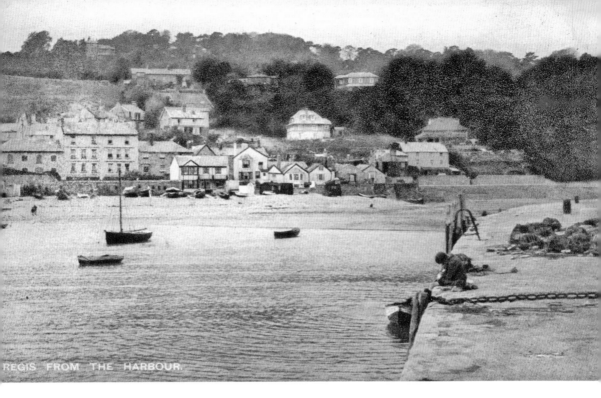

REGIS FROM THE HARBOUR.

A Closer and Later View, *c.* 1920

The viewpoint here is the North Wall itself, today beside one of the ornamental cannons. This old view is a little more recent than the previous one; look at the hillside near the middle of the picture and you will see that a new house has appeared.

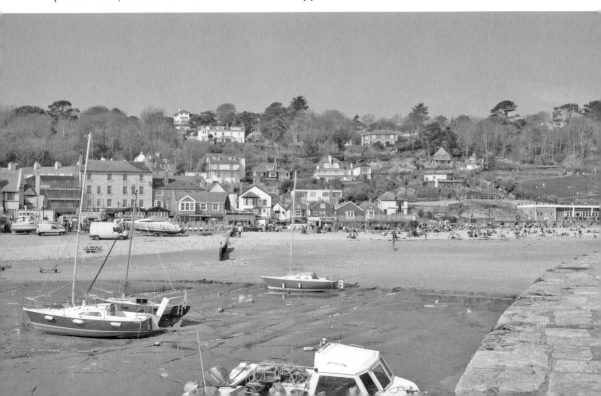

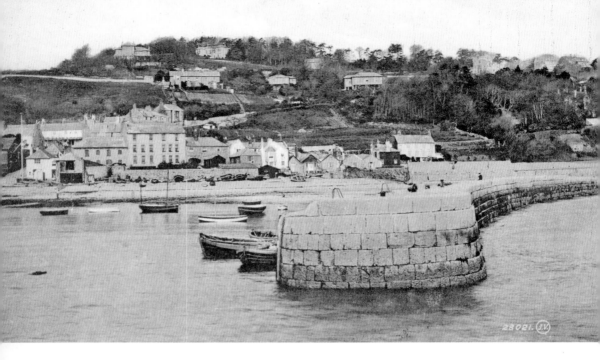

The North Wall, *c.* 1905

We leap back onto The Cobb itself for a view along most of the length of the North Wall. This was constructed in 1849 to replace a smaller predecessor that protected this side of the harbour. Comparing the old and new photographs shows that, like The Cobb, it has undergone changes in its material and alignment. Compare also the buildings on the hillside beyond; the ones in the old view are generally still there today, and of course more have appeared.

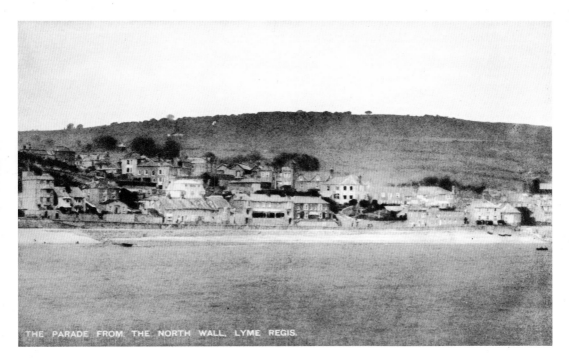

THE PARADE FROM THE NORTH WALL. LYME REGIS.

View of Marine Parade, *c.* **1905**

Next, a pair of views back to the town end of Marine Parade; the old one taken from North Wall, mine from Victoria Pier just behind. The four-storey Sundial, built in 1903 by Arnold Mitchell, is on the left of both shots, though a little obscured by the adjacent hotel today, and at far right the parish church stands above the seafront.

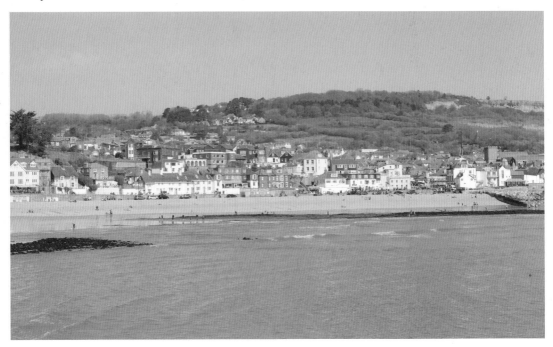

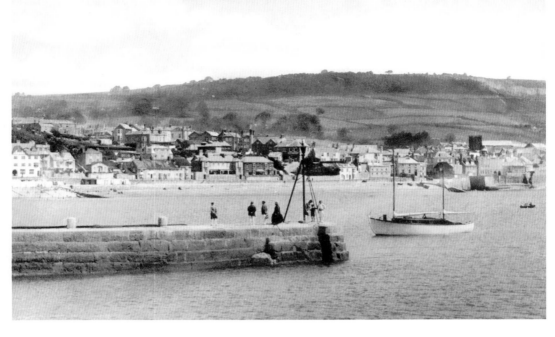

End of Victoria Pier, *c. 1925*

And finally, we head back to its outer section to see a similar stretch of the seafront as before, but now with the end of Victoria Pier in the foreground. The pier is a little longer today than when the old photograph was taken.

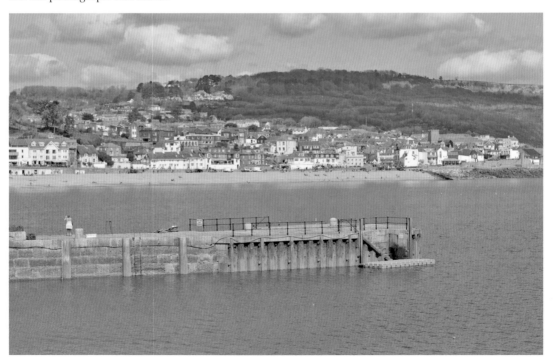

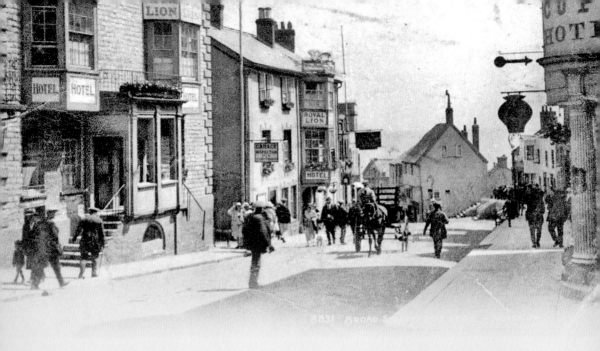

CHAPTER 4

In The Town

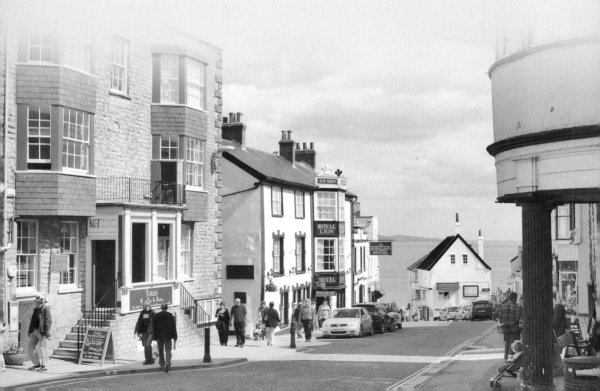

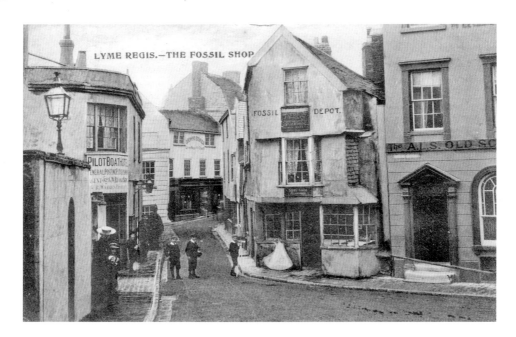

The Fossil Shop, *c.* 1900

In this chapter, we have a look around the town, starting at the lower end where Broad Street and Bridge Street meet. The old image here tells us that visitors were fascinated by the local fossils just as much as they are now, and comparison with my picture shows quite a few changes. In 1913, the road that heads away from us, Bridge Street, was widened, and this involved the demolition of the Fossil Shop and the property behind it. The building to its right in the old view has survived, now renamed the Rock Point Inn, but the public toilets on the left have been rebuilt.

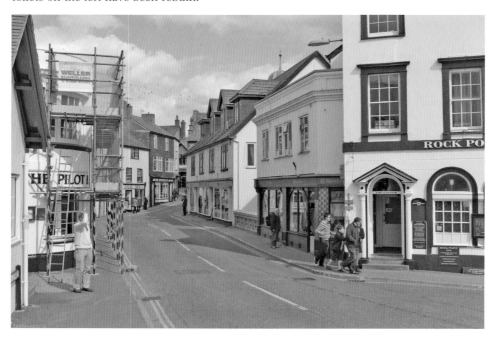

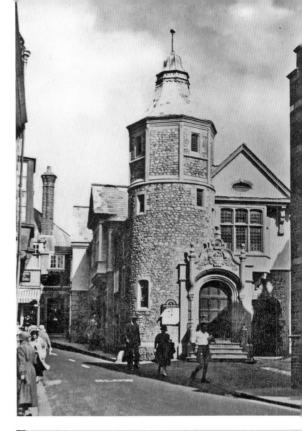

The Guildhall, *c.* 1930
We head along Bridge Street and step back just into Coombe Street for this view of Lyme Regis' Guildhall. The present building was constructed in 1887, incorporating sixteenth- and seventeenth-century features from an earlier guildhall on this spot. Beyond and to the left of the Guildhall, just into Church Street, are the offices of the town council – this building has lost a rather substantial chimney at some point.

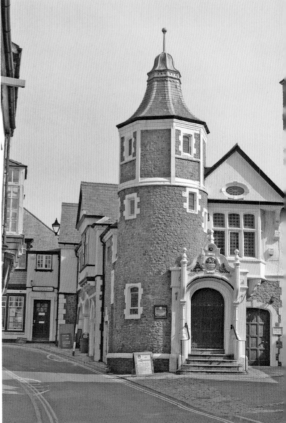

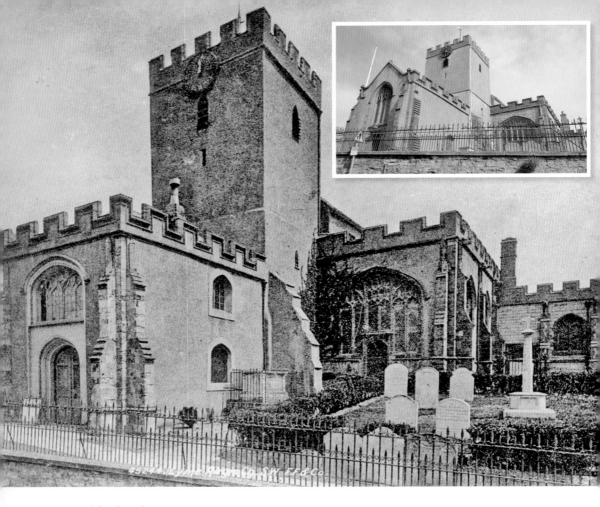

Parish Church, *c.* 1900

As its name suggests, Church Street heads towards the parish church, going inland and uphill on the way. Parts of the building date back to Norman times, and it is dedicated to St Michael. The old view was probably taken from upstairs in what is now Old Monmouth Holiday Let, while mine was from street level. Despite this, there is an obvious difference at this western end of the building. In 1933, the old porch was demolished as part of a scheme that was curtailed due to lack of funds – a new porch was built, but not the flanking aisles that were also planned.

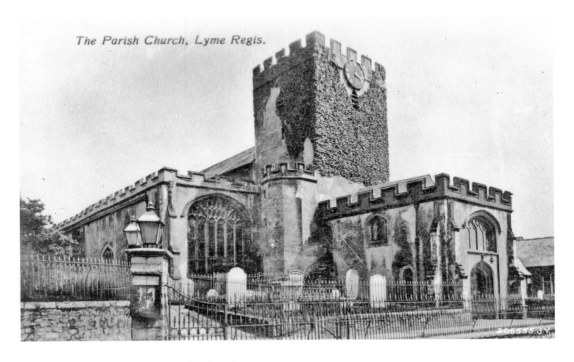

The Parish Church, Lyme Regis.

A More Picturesque Parish Church, c. 1925

This old view must have been taken only a few years before that rebuilding. It shows extensive ivy growth on the church tower, which looked pretty but could have damaged the stonework. This viewpoint shows the entrance at the north-west corner of the churchyard, where alterations have also been made.

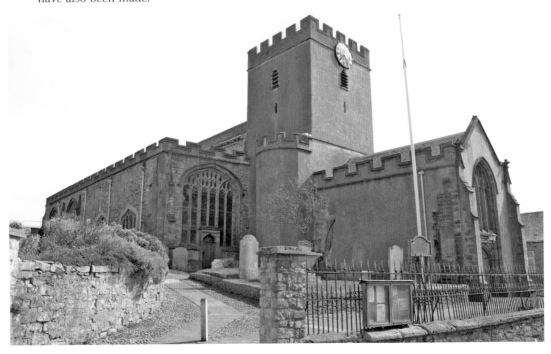

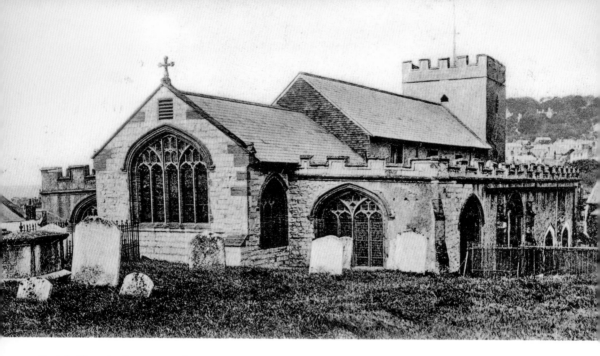

Parish Church, Eastern End, c. 1900

And now, around to the other side of the church for this view of the eastern end, where there have been fewer changes than on the western side. We have already seen the prominence of the church in views of the town from the landward side, and it would also have been a valuable seamark. Its position on the hillside above the old town would have helped those out at sea to identify their position.

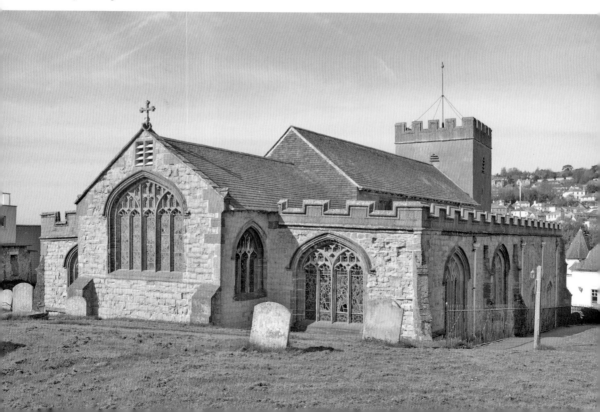

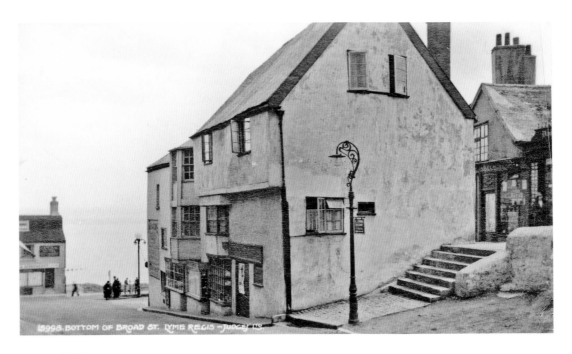

Middle Row, *c.* 1935

We go back the way we came past the Guildhall and over Buddle Bridge for a series of views in Broad Street, the town's main shopping area. A short way up, we look back at a pair of properties sometimes called Middle Row, which divide the road on our left from a walkway up on the right. It is known that the further of these two properties was built in 1598 as a butcher's premises, and the one in the foreground is of a similar age.

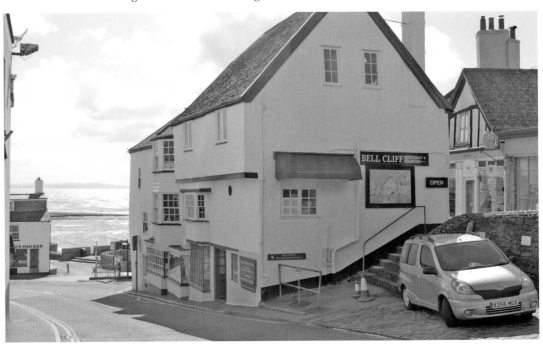

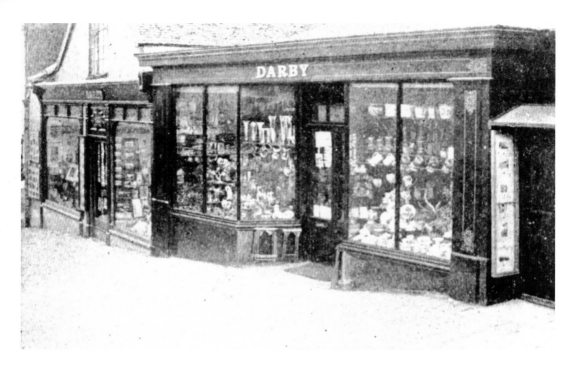

Porcelain Shop, *c.* 1905

Now for some views of individual businesses in Broad Street. The subject here is No. 8, which is on the walkway just to the right of the previous shot. The old picture shows the porcelain shop of W. C. Darby, and though the premises has altered somewhat, this single-storey building is still recognisable today.

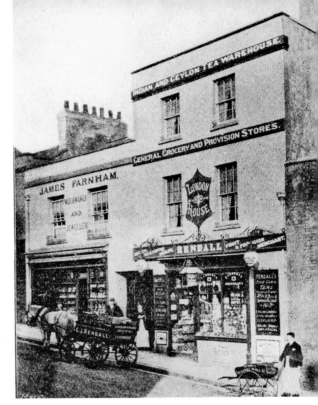

A Grocer's, c. 1905
Diagonally across the street and uphill
was Rendall's grocery business at No. 62, a
distinctive three-storey, nineteenth-century
building. According to a contemporary
trade directory, the owner's full name was
George John Rendall.

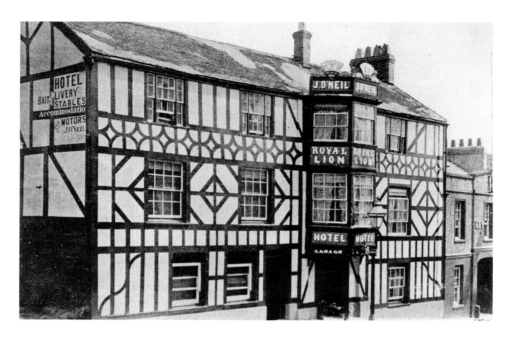

The Royal Lion Hotel, *c.* 1905

A few doors up on this side of Broad Street, we find the Royal Lion Hotel. There has been an inn on this site for over 400 years, although the present building was constructed after a fire in 1844 destroyed its predecessor and other buildings in the town. The most noticeable change in the building since the old photograph was taken is the removal of the decorative timberwork on the exterior. Then, as now, the feathers that are the emblem of the Prince of Wales can be seen on the top of the three-storey porch (presumably a reference to 'Royal' in the name). Today, the Prince's motto 'Ich Dien' is set below, where once the Edwardian proprietor, James O'Neil, had his own name.

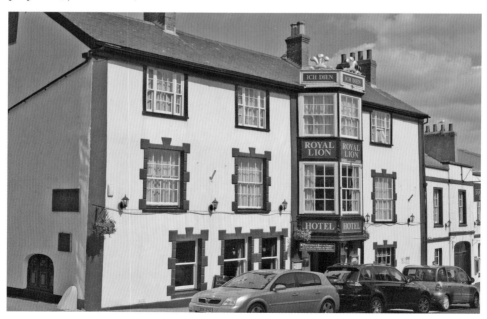

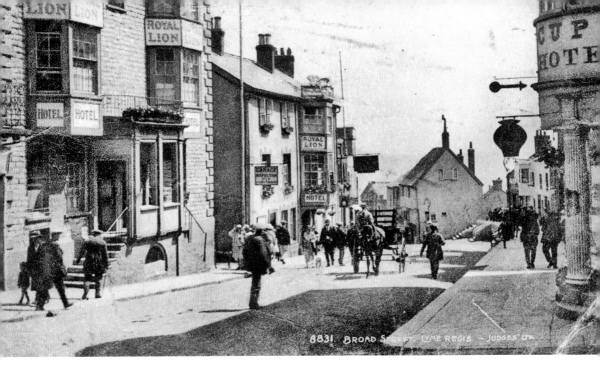

A Wider View, c. 1925

A little further up Broad Street, we get this wider view down the street. Middle Row is in the distance, and the Royal Lion is in the middle of the view – in the old picture it has already lost the decorative timberwork that we saw in the previous view. It is a little surprising to see the words 'Royal Lion Hotel' on the building on the left; it must have been part of the establishment at this time.

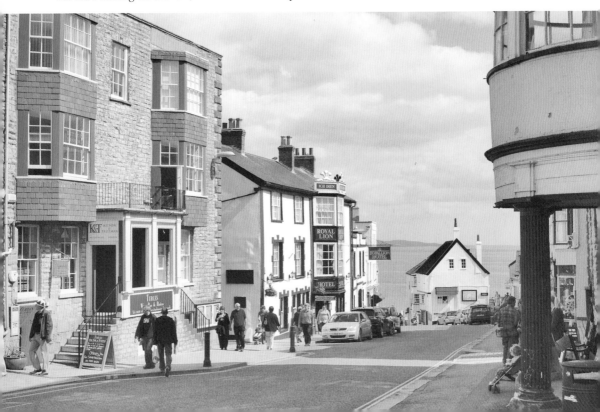

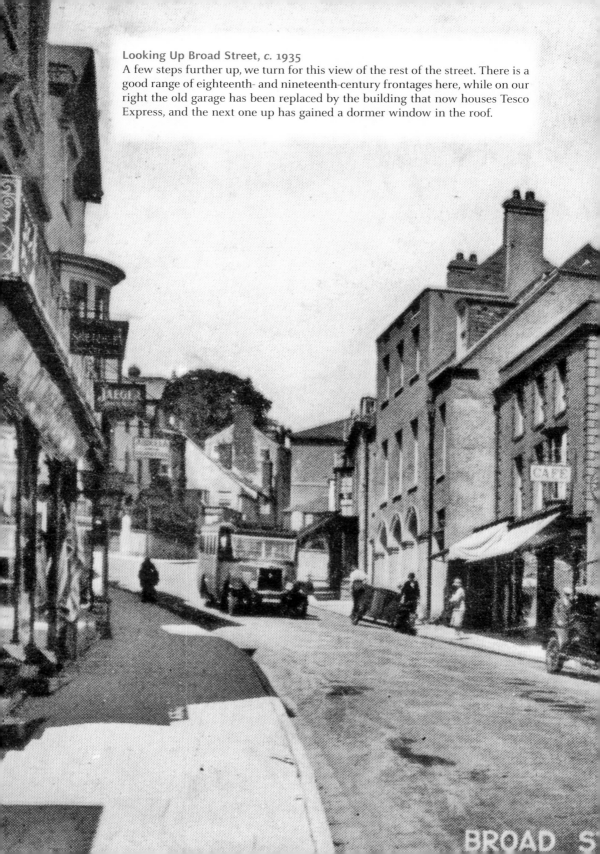

Looking Up Broad Street, *c. 1935*
A few steps further up, we turn for this view of the rest of the street. There is a good range of eighteenth- and nineteenth-century frontages here, while on our right the old garage has been replaced by the building that now houses Tesco Express, and the next one up has gained a dormer window in the roof.

BROAD S

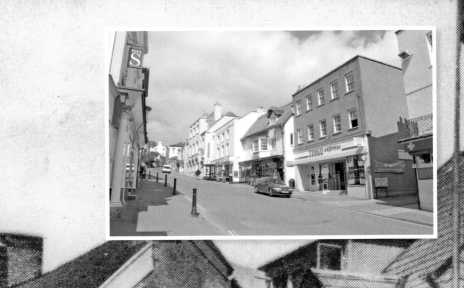

ASTRYCOOKS
NCHEON
TEA
WS

GARAGE

WATSONS GARAGE

"PITT" HOUSE
HOTEL

EET. LYME REGIS.

20

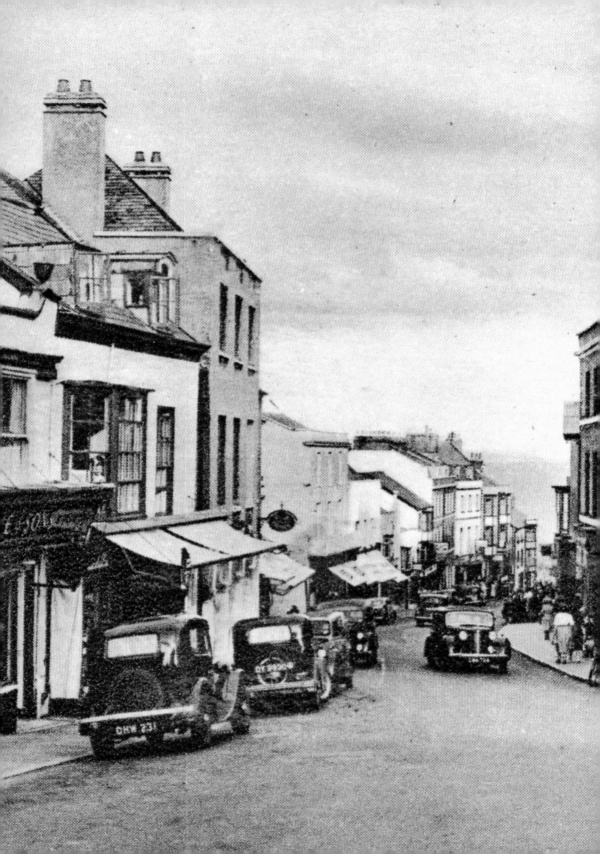

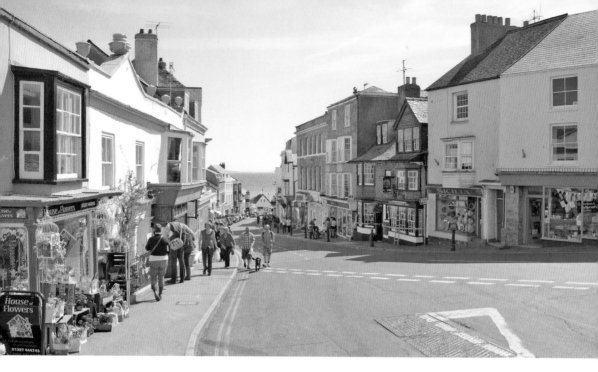

Looking Down Broad Street, *c.* 1905 and *c.* 1935
We continue to the top of Broad Street and look back down. Silver Street, which heads off towards Uplyme, is behind us to the left, and Pound Street goes to the right. Comparing these Edwardian (*below*), 1930s (*left*) and present-day views, there seem to have been relatively few changes in the buildings, which is rather surprising in a British High Street. The most visible difference is in the second building from the right in the oldest photograph, the Volunteer Inn – the frontage looks very different today.

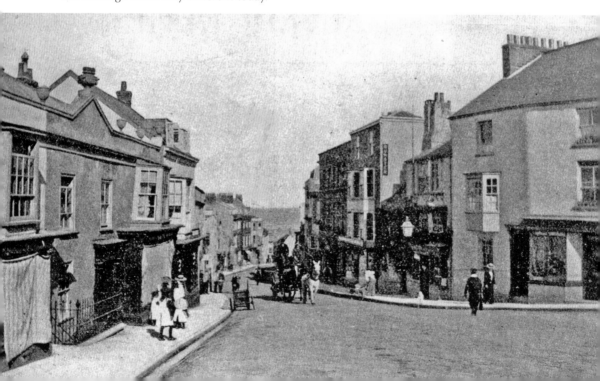

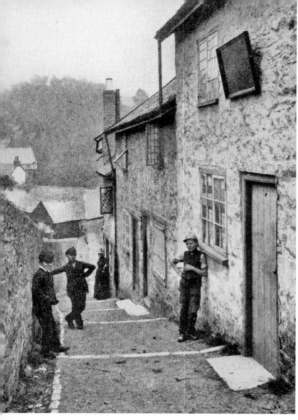

Sherborne Lane, c. 1905

Sherborne Lane begins just to the left of the previous viewpoint, and drops down to the River Lim and Coombe Street beyond – it can be an excellent shortcut for pedestrians wishing to avoid the town centre. The lane's name reflects Sherborne Abbey's former lordship of the town. Here, around halfway down, we see part of a terrace of eighteenth- and nineteenth-century cottages on the right. Comparing the two views, we can see various changes to the doors and windows, as well as in the wall opposite. The house across the valley on the left of the old picture can still be identified among the more modern development.

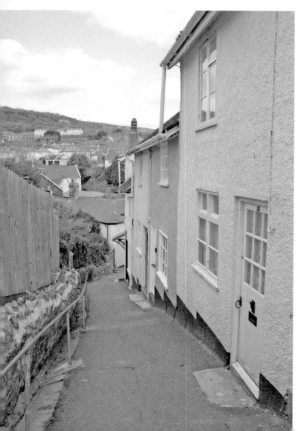

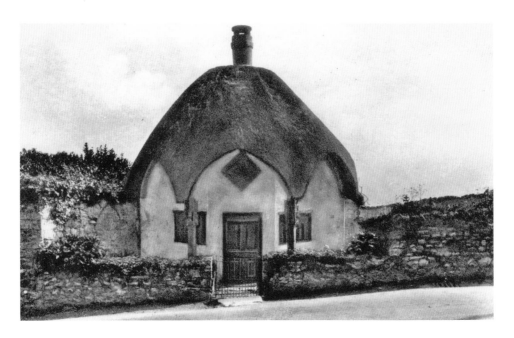

Umbrella Cottage, *c.* 1930

Pound Street is the beginning of the coast road that runs west out of the town, and as it ascends it becomes Sidmouth Road. This side of Lyme has a fine selection of nineteenth-century buildings where architects seem to have let their imaginations run riot, and at the start of Sidmouth Road we find this example. This early nineteenth-century octagonal cottage orné takes its name from its shape, and was originally intended as the home of a gardener. You cannot see it from the angle of my picture, but in recent years the cottage has been extended considerably at the rear in a similar style.

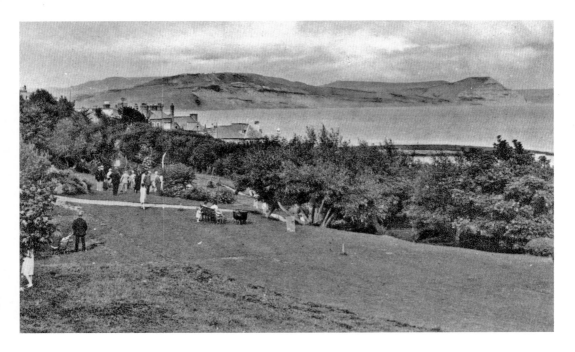

Langmoor Gardens, *c.* **1925**

Partway up Pound Street is one of the entrances into Langmoor Gardens, the park on the cliffs that we saw in several of the shots from Marine Parade. They are also known as the Langmoor and Lister Gardens, after Joseph Lister, the pioneer of antiseptic surgery (1827–1912). When he was made a baronet in recognition of his work, he chose the title Baron Lister of Lyme Regis because he and his brother owned a holiday home here. This view is close to the Pound Street entrance, and looks east along the coast toward Golden Cap.

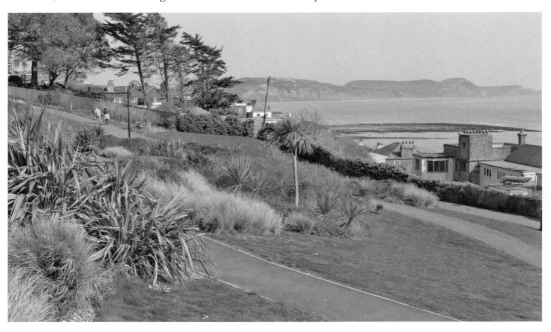

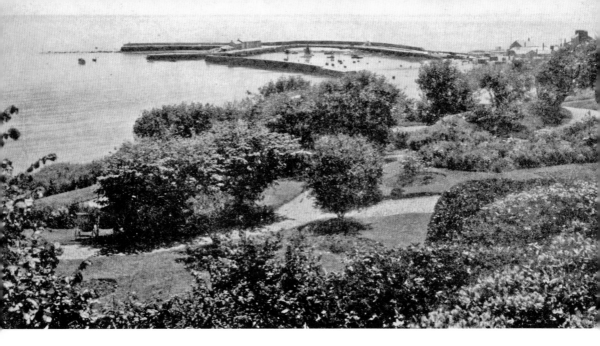

Cliff Stabilisation, *c.* 1930

The cliffside on which the gardens were built are inherently unstable, like much of the local geology, and several major landslips have occurred here since Victorian times, affecting not only the gardens but also surrounding properties. In a bid to deal with this problem, between 2006 and 2011, as part of the Lyme Regis Environmental Improvement Scheme, West Dorset District Council and the town council undertook major stabilisation works that effectively removed all the features of the gardens. This pair of views, therefore, testifies just how successful the subsequent restoration was, particularly as the paths in the old and new pictures seem to be in the same locations.

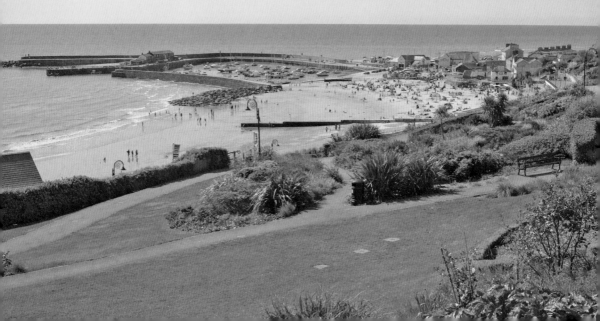

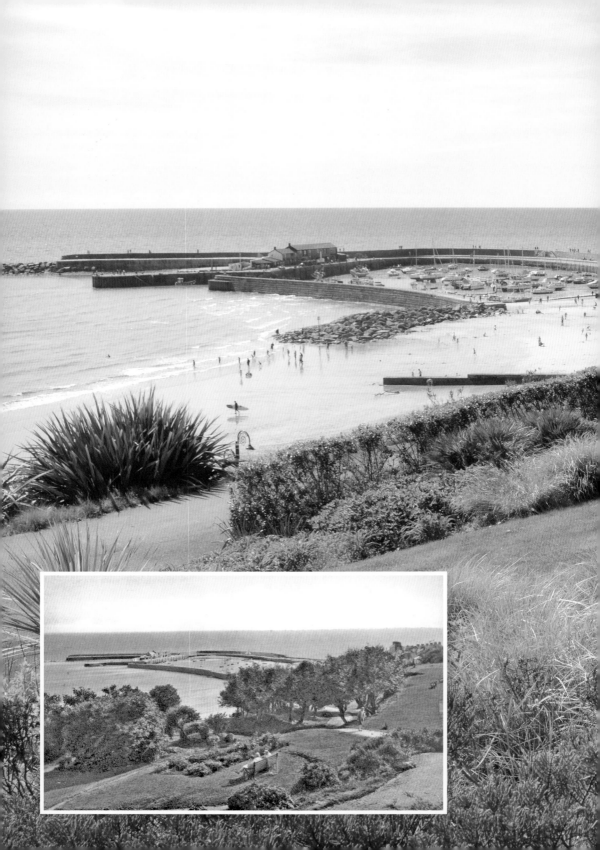

Another Look, *c.* 1925

As in the previous pair, this view looks south-west towards The Cobb from a location a little to the right of those before. In this case, though, I could find an exact match for the features in the old picture.

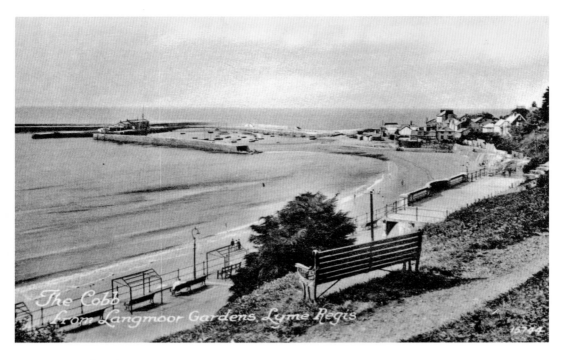

Lower Down the Slope, *c.* 1930

Here is another view from the bottom of the gardens. The top of the Jubilee Pavilion is on the right of the old and new photographs, and the latter includes the tops of the Marine Parade Shelters that were also restored following the recent cliff stabilisation works.

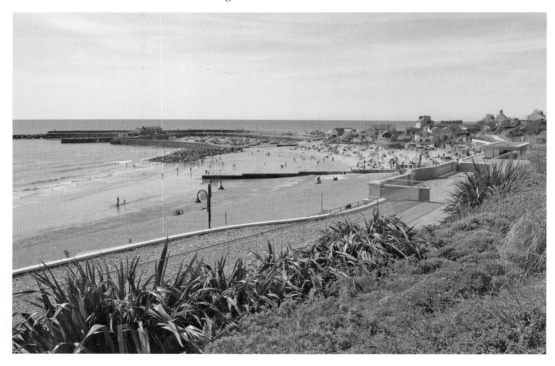

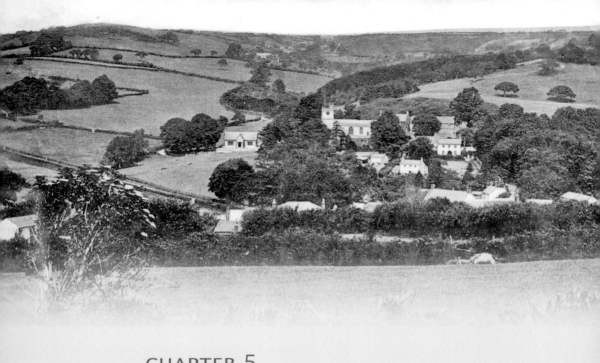

The Countryside and Heading West

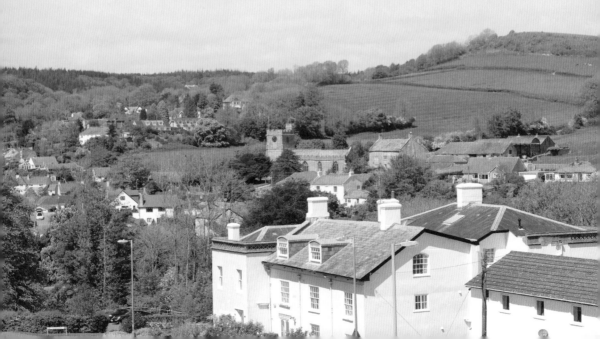

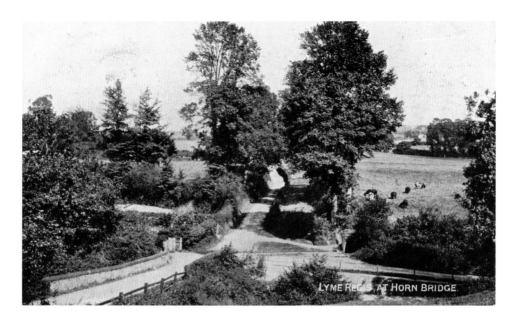

Horn Bridge, *c.* 1900

In this chapter, we travel westwards out of Lyme Regis on the opposite side from Charmouth. About half a mile upstream from its source, the Lim is crossed by Horn Bridge, which is at bottom left of the old picture. It dates from the eighteenth century, and takes Colway Lane over the river. Until a new road was built to the east in the early nineteenth century, this was the only route into Lyme for horse-drawn vehicles. At the time the old photograph was taken, the area was still countryside, and although some housing has now extended this far, the original viewpoint now lies within the Woodland Trust's Slopes Farm site. I visited during emergency road repairs!

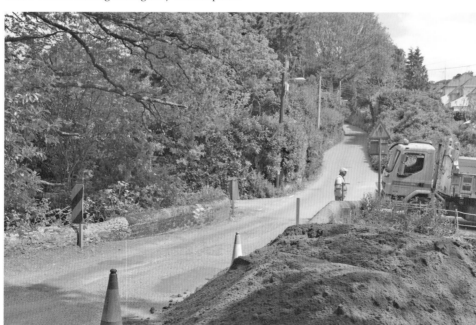

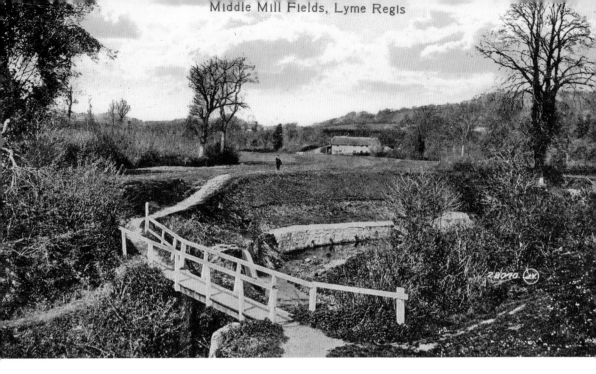

Bridge Near Middle Mill Farm, *c.* 1905

Middle Mill Farm lies close to the River Lim a few hundred yards upstream from Horn Bridge. There are at least three footbridges on this stretch of the river, but the one I have photographed seems the best candidate to me. It lies just upstream of the farm, and though the area is now much more overgrown and the bridge has been reconstructed in metal, it looks like a reasonable match.

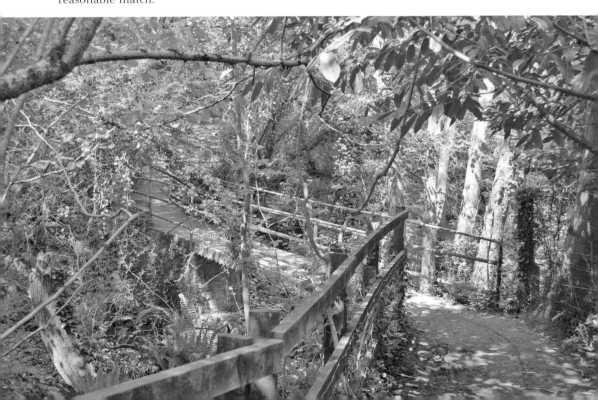

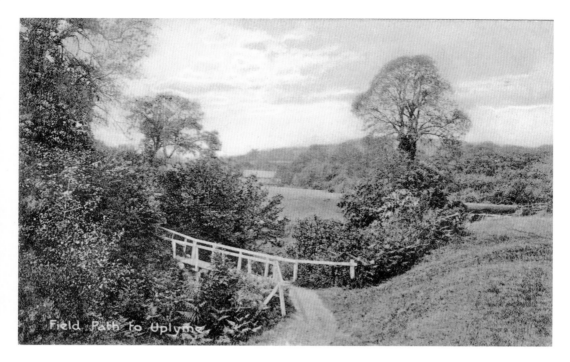

Field Path to Uplyme

Reverse View, Maybe, *c.* 1905

I think that this old picture might be a reverse view of the previous, looking downstream and south-eastward. However, I am not entirely convinced, and if you are in the area, you might like to look for yourself. This is, after all, fine walking country, with the Wessex Ridgeway and Liberty Trail long-distance footpaths passing through.

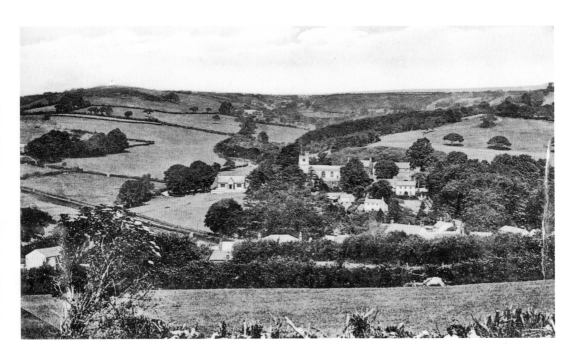

Uplyme, *c.* 1910

The appropriately named village of Uplyme lies a little further up the valley, at a distance of a mile and a half from Lyme Regis town centre, and just across the border into Devon. Today, development along the B3165 just about links village and town. The old picture was taken from Whalley Lane on the south side of the valley, I believe. That view is now blocked by development on that lane, so mine was taken from the footpath that drops down from the lane to the main road. The Devon Hotel is in the foreground of my shot.

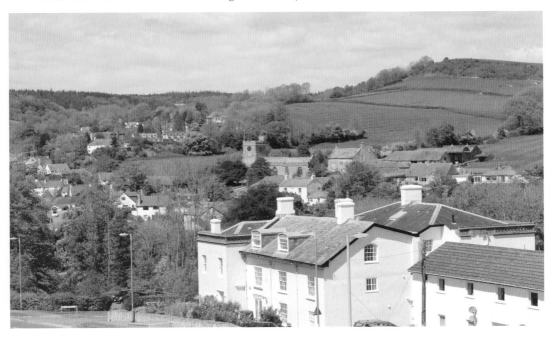

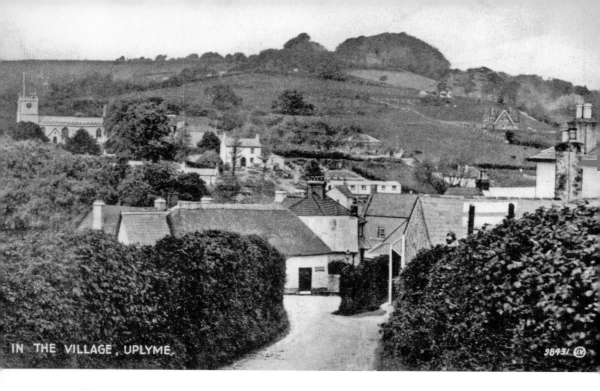

IN THE VILLAGE, UPLYME.

98431

In the Village, *c.* 1930

We drop down into the village for a closer view. The viewpoint of the old picture is in Gore Lane (which runs south from the village to the coast road at Ware), probably where the junction with Venlake Close is today. At upper left we see Uplyme's parish church, much of which dates from the fourteenth and fifteenth centuries.

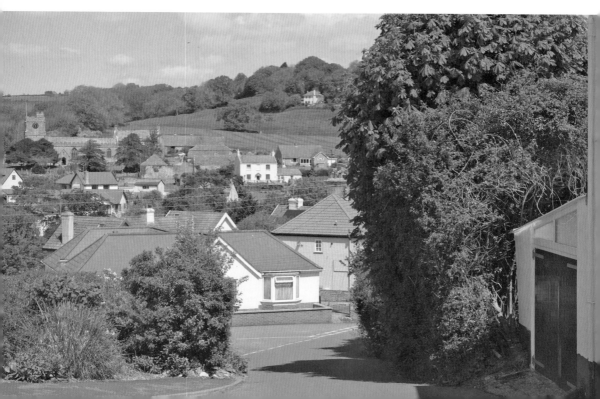

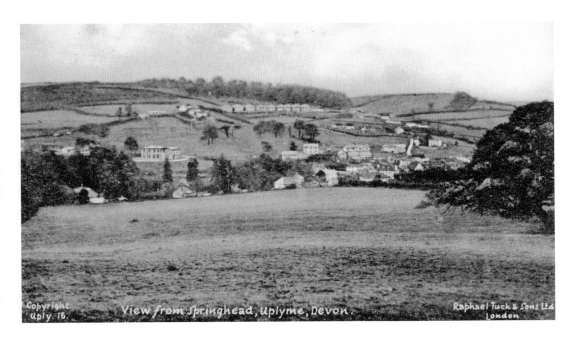

View from Springhead, Uplyme, Devon.

Uplyme from the North, *c.* 1930

Next, we head across the valley to see the village from the opposite side, and to get a good impression of how much it has expanded. The viewpoint of both old and new photographs is a footpath that runs uphill and north-east from the parish church to Spring Head Road. Among the buildings we can see are the housing on Whalley Lane on the far hillside (mentioned a couple of pages back and which must have been new when the old photograph was taken) and, in the valley on the left, the Devon Hotel on the main road, built 200 years ago as a rectory. For a reason that I cannot quite fathom, the parish church that is so prominent in my photograph is very difficult to make out in the old one.

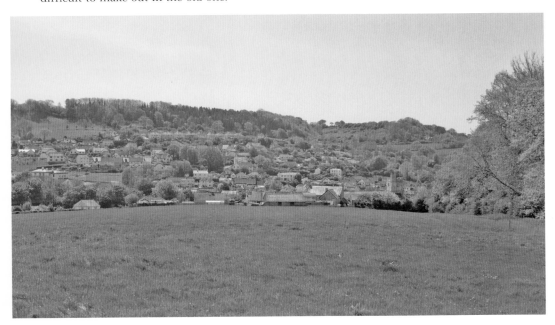

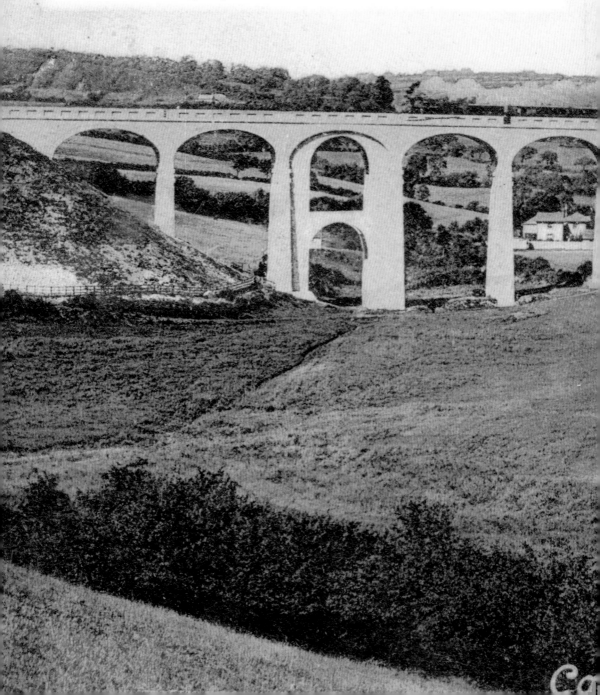

Cannington Viaduct, c. 1905

A mile and a half or so south-west of Uplyme, a tributary of the Lim runs through a steep-sided little valley. The railway did not reach Lyme Regis until 1903, probably because although the town was quite close to a main line, the terrain made construction difficult and expensive. The line that opened that year crossed the little valley over this spectacular stone viaduct. Evidence of the difficulty experienced by the builders can be seen in the brick-strengthening in the third arch from the left, added at the time of construction or soon after. The line closed in 1965, and today the odd tree is taking the place of the trains.

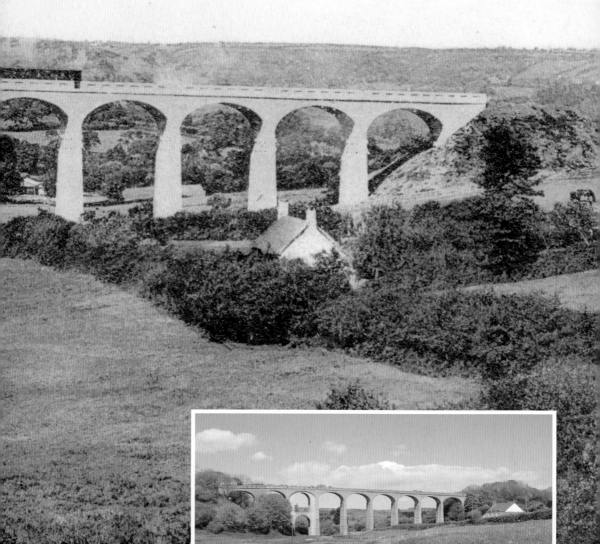

inaton Viaduct Lume Regis

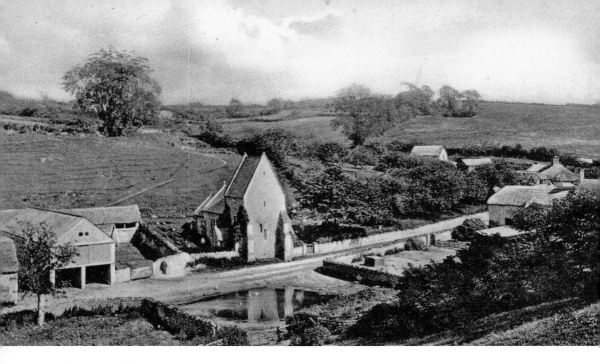

Combpyne and its Church, *c.* 1905

Follow the lane from where I took the previous shot roughly westwards for a couple of miles and you reach the little village of Combpyne. The old view here was taken from private land. The village pond (which is still there today) is near the centre, and from this angle the building beyond it may not be immediately recognisable. It is actually the extraordinarily shaped parish church, which dates from around 1240 and is the sole subject of my picture.

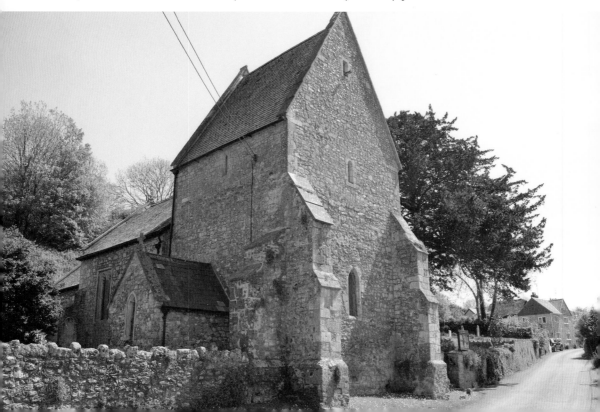

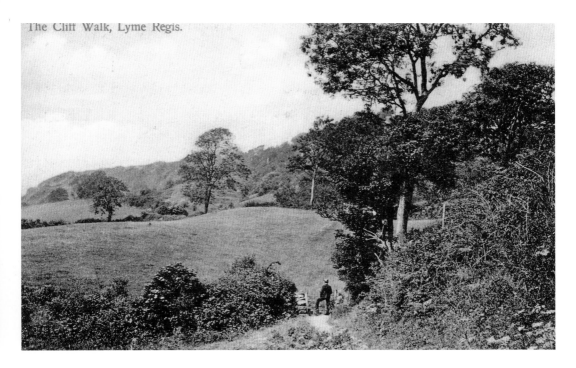

Cliff Walk, *c.* 1905

Back closer to Lyme Regis now, and a location that I had some difficulty finding. At first I thought it was on the east side of the town, but after some exploring I think the old picture was taken on the west side. The viewpoint of my photograph looks west from just inside Dorset, on the path that heads towards the Undercliff – the hedge in the foreground is the Devon boundary. A nearby gateway through an overgrown area may be the actual one in which the Edwardian gentleman is standing. Again, you might like to go there and judge for yourself.

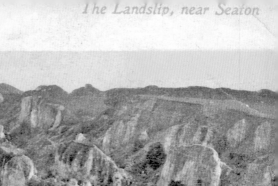

The Undercliff, Both *c.* 1905

And now for some views of the Undercliff itself. This is the extensive area along the coast between the edge of Lyme Regis and the mouth of the River Axe near Seaton, which has been partly detached from the mainland by a series of massive landslips, of which the one in 1839 was the greatest and best known. The resulting chasms that separated off this area are illustrated well in the two old photographs. These prevented access for any vehicles and made farming impossible, so that the area quickly reverted to a wild state and woodland has been developing ever since. Comparison of the old photographs and mine illustrates this continuing process. The Undercliff is some 5 miles long, and a footpath runs through it. The landslips are ongoing, so a section of this footpath was closed at the time of writing, but when fully open this is a superb walk. However, once you start the walk the only way out is to finish it or return to your starting point, so walkers are always advised to have proper supplies before heading into this 'lost world'.

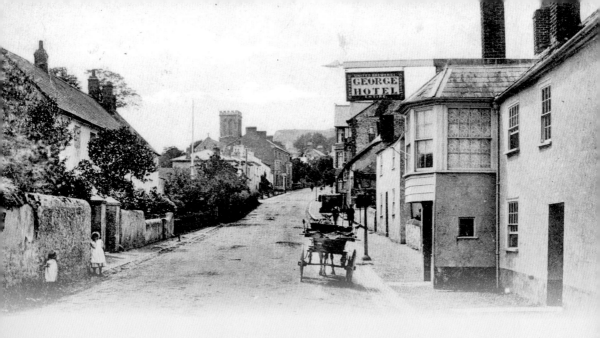

CHAPTER 6

Charmouth

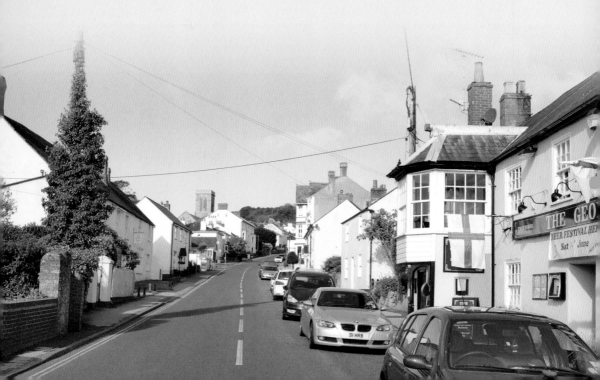

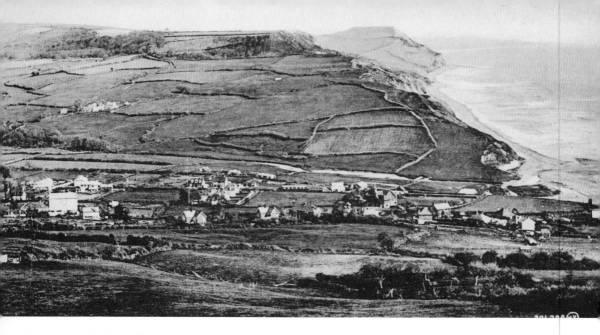

Charmouth from the West, *c.* 1930

Charmouth lies along the coast to the east of Lyme Regis, at a distance of about two miles as the crow flies, though those who have to drive around can add another mile to this distance. As the name suggests, it lies by the mouth of the River Char, and is one of those places you could argue a case for it being a town just as easily as a village. Charmouth started life in the thirteenth century, being laid out along the coast road as a planned town on land belonging to Forde Abbey over on the Somerset border. The monks' plan was that it would profit from trade along that road, but it was not until the ninteenth century and the arrival of the tourist industry that Charmouth expanded to fill the area that had been laid out for it six centuries previously. The old view here looks down from the hillside of Black Ven onto the land between Charmouth's centre and the coast, into which the settlement was expanding in the late ninteenth and early twentieth centuries. My picture was taken from lower down, at the highest available viewpoint along the coastal path, which was closed a short distance further up. It shows how the lowland west of the river is now filled by housing.

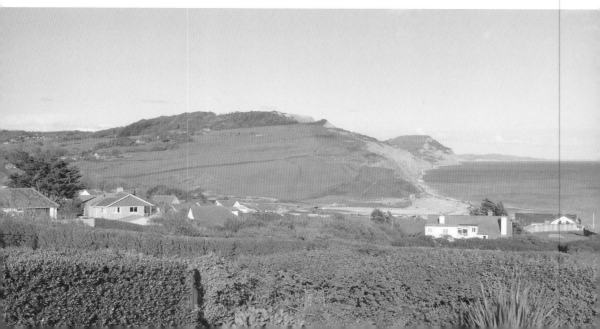

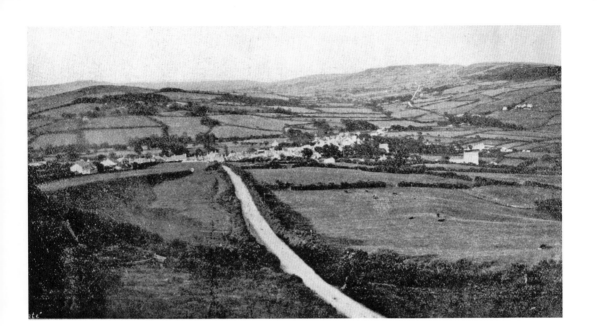

Charmouth's Old Centre, *c.* 1905

The old image here gives us a good idea of the layout of the medieval planned town – effectively a row of properties on either side of a single street. The old picture was taken from just above Old Lyme Road, then one of two almost parallel roads that left the western end of Charmouth, joining up after about a mile and heading over the clifftops to Lyme Regis. We saw the end of this long-closed route in the picture of the Timber Hill road early in this book (page 8). My picture was taken at road level, and illustrates the subsequent development of this area.

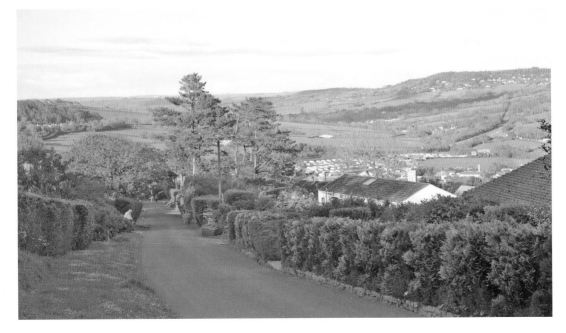

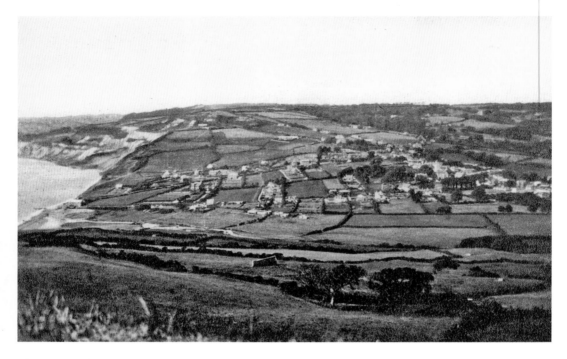

Charmouth from the East, *c. 1930*

We go across to the other side of the Char valley to look down on Charmouth from Stonebarrow Hill on its east side. This is a wider view than the previous ones, allowing us to see the old centre on the right and the coastward expansion. Note that there is a ruined building in the foreground of both shots.

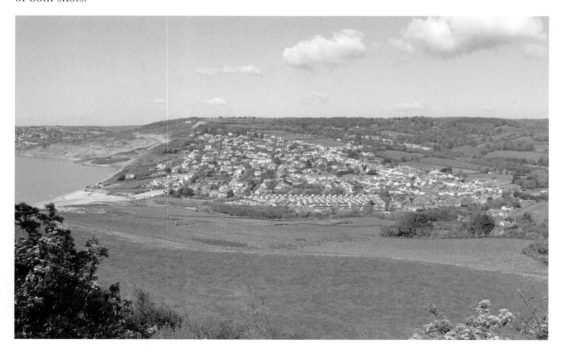

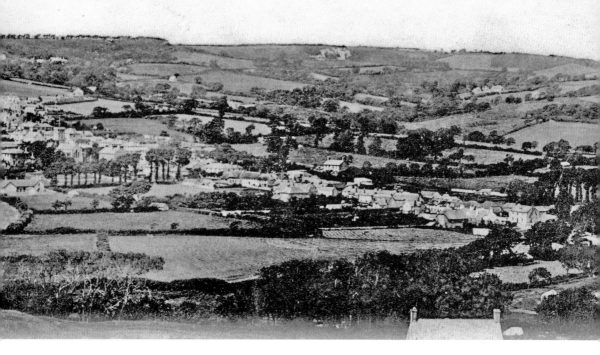

Down the Hill, *c.* 1910
We descend partway down the hillside for a clearer view of the lower end of 'old' Charmouth. The tower of the parish church, which occupies a fairly central location on the main street, can be made out near the left edge of the view. The street drops down to cross the River Char and a tributary around the right edge of shot.

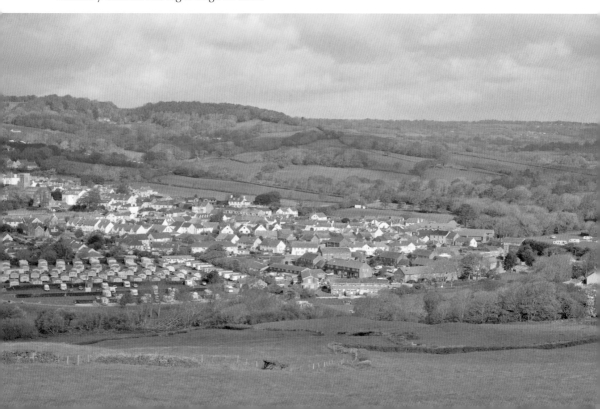

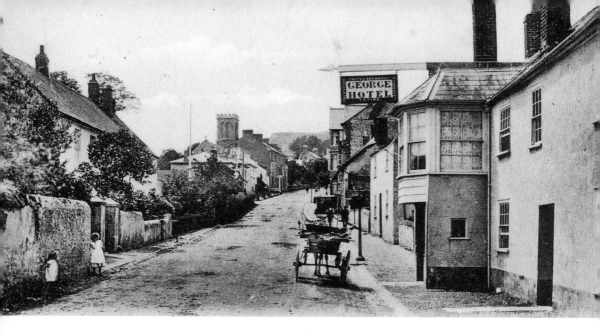

The Street and the George Hotel, *c. 1900*
Next we drop down into Charmouth itself, and look up what is simply called The Street from close to its eastern end. In the distance we see the church tower, and on the right there is the George Hotel, parts of which date to Tudor times, and which was originally a coaching inn.

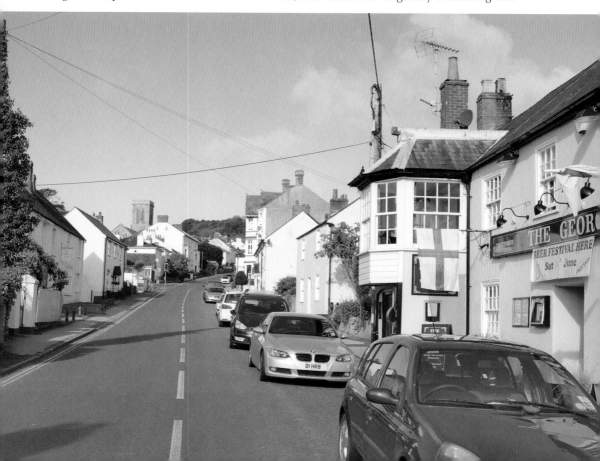

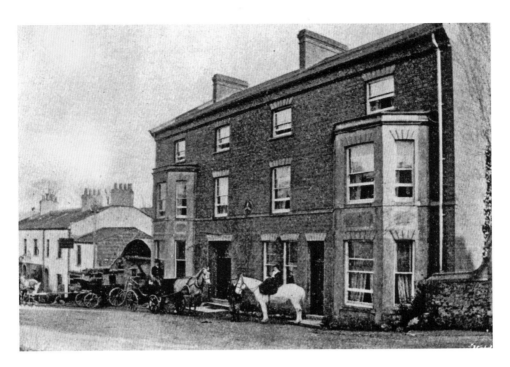

The Coach and Horses, c. 1905

Partway up The Street, on the south side just before the parish church, we find what was once the Coach and Horses Hotel. This was built in the 1880s on the site of a pub called the Three Crowns. The proprietor's name around the time the old picture was taken was one Alexander Cox Pagan. The hotel ceased trading in the 1990s, and has since been converted into apartments.

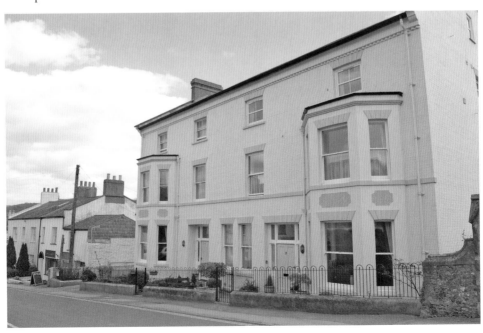

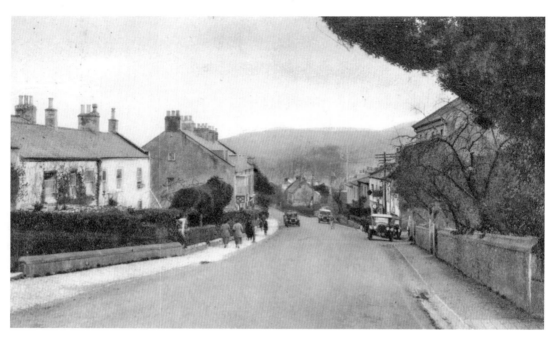

Houses, *c.* 1920

Moving on a short distance, we turn round for a look back down The Street. To our right is the churchyard wall, with the Coach and Horses just beyond it. To the left, we see some of the fine nineteenth-century properties that were built in Charmouth as the place prospered thanks to the tourism industry.

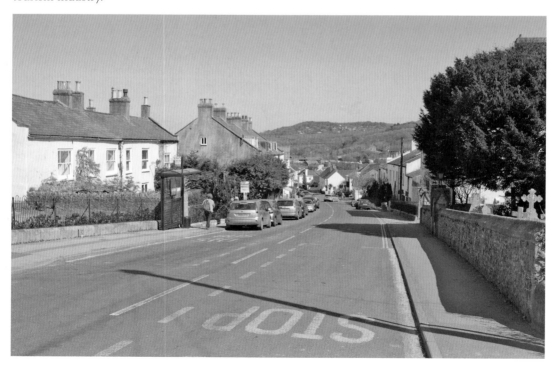

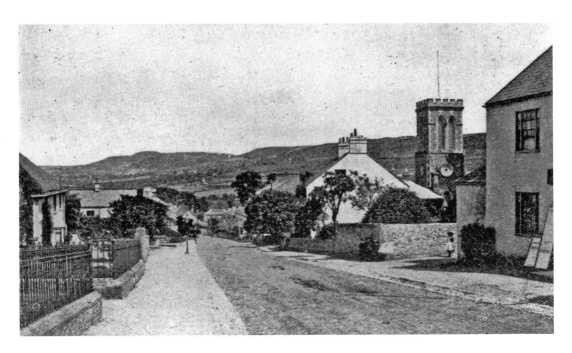

The Parish Church, c. 1905

We continue uphill, crossing the road for a view of the parish church. Although there would have been a church in Charmouth right from the time of its foundation (the monks would have seen to that!), the present building dates only from the 1830s. A couple of other points to note are that the building on right has been extended since the old picture was taken, and that today Charmouth Library, which is not visible in my photograph, occupies the gap between it and the church.

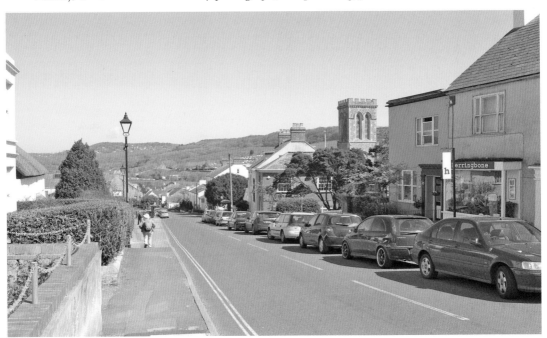

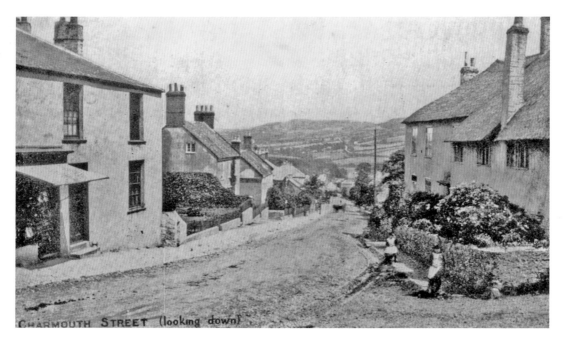

CHARMOUTH STREET (looking down)

The Western End, *c.* 1900

Our final view of The Street is from its junction with Higher Sea Lane, which is coming in from the right of this shot. This is at the western boundary of the medieval planned town. Among the changes that can be seen in the old and new photographs, the building on the left is no longer a shop, and that on the right, Charmouth House, has lost a sizeable chimney. Charmouth House was formerly a hotel and dates from the seventeenth century.

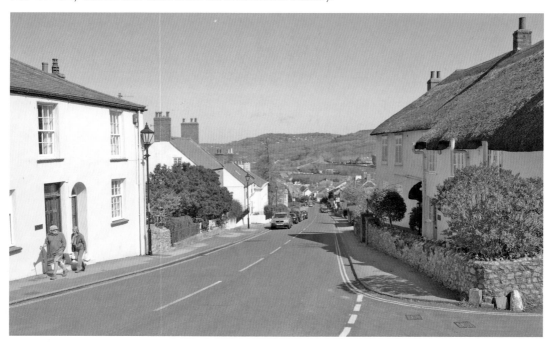

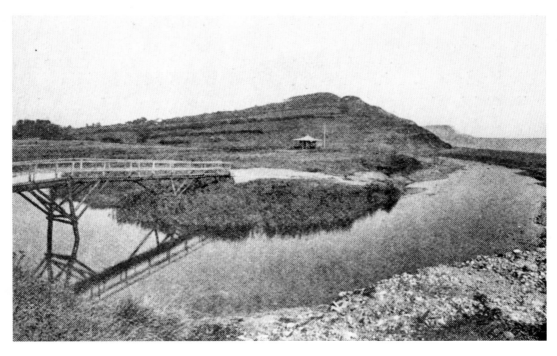

The Mouth of the Char, *c.* 1905
Down to the coast now for a look at the river mouth, with the lower slopes of Stonebarrow in the background. There have been various changes to the river mouth and coastline here, and the footbridge has been rebuilt and relocated more than once.

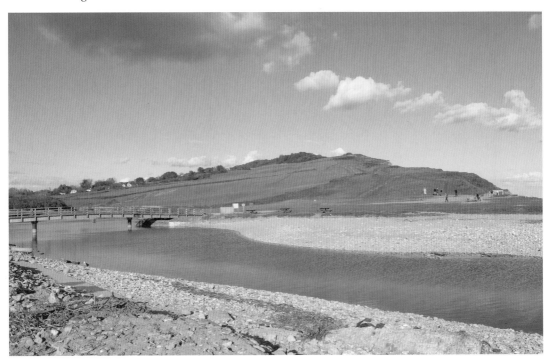

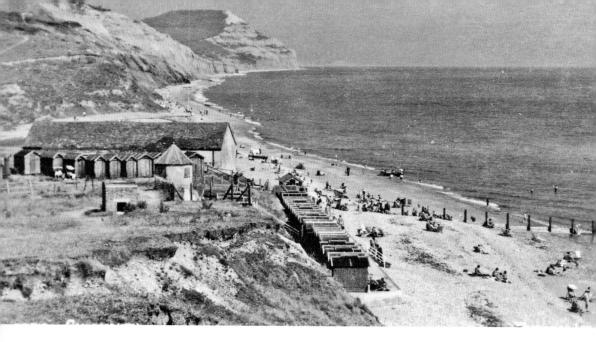

The Look Out, *c.* 1925

To finish, we head a short distance back up the coast path for a wider view across the river mouth with Golden Cap in the distance. The Look Out is the small, octagonal building that is clearly visible in the old picture, but obscured by beach huts in mine. This was built in 1804, during the Napoleonic Wars, as a look out for French invaders, but it spent most of its working life in the use of excise officers watching for smugglers. A sign on the door proudly boasts that it is one of only six such buildings to survive in this country. There are clear signs of erosion in the foreground of both views, and the cliff edge has moved somewhat in the intervening years.

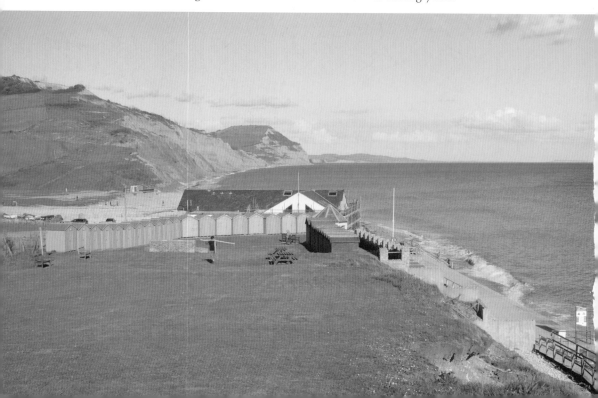